Art Therapy with Children on the Autistic Spectrum

of related interest

Autism and Sensing
The Unlost Instinct
Donna Williams
ISBN 1 85302 612 3

Autism and Play
Jannik Beyer and Lone Gammeltoft
ISBN 1 85302 845 2

Bright Splinters of the Mind
A Personal Story of Research with Autistic Savants
Beate Hermelin
ISBN 1 85302 932 7 pb
ISBN 1 85302 931 9 hb

Asperger's Syndrome
A Guide for Parents and Professionals
Tony Attwood
ISBN 1 85302 577 1

Art Therapy and Computer Technology
A Virtual Studio of Possibilities
Cathy Malchiodi
ISBN 1 85302 922 X

Art Therapy with Children on the Autistic Spectrum

Beyond Words

Kathy Evans and Janek Dubowski

Jessica Kingsley Publishers
London and Philadelphia

First published in the United Kingdom in 2001 by
Jessica Kingsley Publishers Ltd
116 Pentonville Road
London N1 9JB, England
and
325 Chestnut Street
Philadelphia, PA 19106, USA

www.jkp.com

Library of Congress Cataloging in Publication Data
A CIP catalog record for this book is available from the Library of Congress

British Library Cataloguing in Publication Data
A CIP catalogue record for this book is available from the British Library

ISBN 1 85302 825 8

Printed and Bound in Great Britain by
Athenaeum Press, Gateshead, Tyne and Wear

Contents

Figures

Introduction

The application of art therapy for children with autism is not something new. As the profession has developed since the 1960s and 1970s, countless practitioners have contributed to the educational and treatment programmes offered to autistic children in settings such as special schools and social services departments as well as in private practice. Different models of art therapy have been developed, ranging from working developmentally by helping individuals to move from one stage of drawing development to the next, to intervening psychotherapeutically with a focus on the alleviation of psychological problems and distress. Some of these models are discussed in this book together with an emphasis on the particular approach we have been developing since the mid-1990s.

As our insight into the conditions associated with autism grows, our understanding of effective forms of support or intervention becomes enhanced. In this book we explore our understanding of the art produced by children with autism and how art therapy may be able to help them. From the perspective of contemporary child and infant psychology with a particular focus on emotional development and relationship as informed by studies into intersubjectivity, we attempt to provide a model of intervention that addresses the severity and complexity of disability associated with deficits in communication and imagination characteristic of autism.

Among the various developmental deficiencies to be observed in children with autism, deficits in communication and imagination are very apparent. Although the majority of autistic children do develop

language, language use is often idiosyncratic and may involve echolalia, repetition and delayed processing.

There are many parallels to be found when observing the play of children with autism, for example the repetitive building of towers out of Lego bricks or the lining up of crayons in a specific order of colour. The play is not what we would term 'imaginative': it does not involve pretend play nor does it suggest that the child has the capacity to imagine that an object can stand for something else. While for the normal child a banana can stand in for a telephone receiver, or a broom handle may represent a hobby-horse, for the autistic child they will always be bananas and broom handles.

These examples give an indication of the severity and complexity of disability associated with deficits in communication and imagination that are characteristic of autism. Among the many forms of intervention that have been and are being applied in helping these children to work through these disabilities, art therapy appears to be promising. When we make a picture it is a communicative act, we anticipate and hope that the viewer, whether this is the child's mother or the artist's public, will understand something about what has been depicted when they view the image. The creative act, necessary in the making of art, is itself an act of imagination. It involves the translation of an internal image in the mind into a tangible form on the sheet of paper. Later on we shall describe the developmental processes by which a normal child gains the capacity to make images that are both communicative and imaginative and we shall explore what it is within autism that interferes with these processes.

In the same way that many children with autism develop language but use it in an idiosyncratic and inappropriate way, these children often learn how to make representational images. Indeed we have celebrated cases of individual children who have shown a remarkable ability and talent in their drawing, the most notable examples perhaps being Nadia and Steven Wiltshire (Selfe 1977, 1983). However, in

our work, time and time again, we come across the same idiosyncrasies and inappropriateness in image making as are found in languages.

These observations and questions form the starting point for our inquiry into the art of children with autistic spectrum disorder. As art therapists we imagine that art could help, at a fundamental level, the development of both communication and imagination but in our work we have developed a number of cautions that need to be observed. It is more the act of making an image and all that is involved in this act that it is important to understand than the final image itself. Indeed, we have frequently found that an analysis of the final image alone gives a misleading understanding or interpretation of what is going on for the child. In the same way that high-functioning autistic children's vast vocabulary might lead us to assume that they have sophisticated communicative skills, the draughtsmanship exhibited by children such as Nadia and Steven Wiltshire might lead us to suppose that they have developed sophisticated channels for graphic communication.

It is important to understand something about normal drawing development in childhood before we can see how the condition of autism affects this. In this book we shall make such comparisons and demonstrate some of the drawing processes developed by autistic children. This will be done in the context of art therapy, in which the therapeutic relationship between client and therapist is as important as the art-making process itself.

We shall show how this is paralleled in normal development in the non-verbal communicative dialogue that takes place between the child, other people and the art work that they are engaged in. Pictures are a form of communication and the development of this does not take place in isolation but within a complex relationship that involves these three elements: the child, the image and the spectator. This tripartite relationship is reflected in the therapeutic environment: the client, the therapist and the image. The model of art therapy

described in this book is largely based on directly translating our understanding of what takes place in normal childhood development into the therapeutic situation. As such we shall also focus in large measure on precursor development in infancy that is considered to be a necessary foundation on which the capacity for imagination and symbolisation can grow.

Children with autism are exposed to art from a number of directions. Most special schools have an art department and the use of art materials is clearly encouraged. Many other forms of intervention such as TEACCH, Makaton and PECS[1] heavily rely on pictorial images. This book will clarify the differences between the capacity to recognise representational images and the capacity to generate them. While these two processes are clearly related we shall show that in many respects they are very different.

The stereotypic and repetitive behaviour witnessed in many children with autism can be understood as avoidant behaviour in so far as the repetitive acts serve to cut out extraneous stimuli that might be experienced as overwhelming or even painful for the child. We have noted similar forms of repetition, even within seemingly complex representational images made by some of the children we have worked with. We shall demonstrate how to recognise this phenomenon and we shall describe how we have developed a number of strategies designed to work with this and indeed to help the child to move into a freer and more relaxed relationship with the art-making process.

This book is for parents of children with autistic spectrum disorder who want to have a better understanding of creative development. It is also for teachers, other professionals working with people with autism and for art therapists themselves. There is still a great deal of confusion about the differences between art making as an element of play, of art education and the use of art-making processes in art therapy; we shall attempt to clarify some of this confusion. If pictures

are regarded as objects with communicative value that do not rely on words, can a form of therapy based on art help people who have difficulties with language to communicate? In other words do art and the art-making process provide an alternative means of communication for individuals with deficits in language development?

At this point we shall briefly plot the journey we have taken in developing our work. Janek has been a qualified art therapist for over twenty years; he has spent considerable time working with people with developmental delay, including those with severe to moderate learning disabilities as well as people with autism. Kathy initially acquired her interest in communication difficulties through her experience as the mother of a profoundly hearing-impaired son. During his early years she developed different ways of using art and body language to communicate with him. This experience led her to develop an interest first in art, gaining a degree in Fine Art as a mature student, and then going on to train as an art therapist.

In the 1980s Janek advocated a model of developmental art therapy (Dubowski 1990) for clients with communication and learning disabilities, based on the assumption that the ability to communicate iconically (with pictures) develops through a series of stages that parallel language development. He also stressed a point about language use itself that he felt is often missed, that as well as allowing for communication with others (intercommunication) we also use language in a very personal way, internally, in our minds, in order to make sense of the world (intracommunication). Language used in this way allows us to communicate with different aspects of our existence, our awareness, between our thoughts and our feelings, our sensations of the world and our intuition about those sensations.

Without some form of language it is difficult to imagine how a person makes sense of all these different and complex stimuli. Although we are not born with language, we are born with the potential for it. It is through interaction with other language users, in

particular our parents or primary caregivers, that this innate predisposition for language unfolds. Many of the patients we work with lack this ability. Some may have learned a few words, others seem to respond appropriately to things said to them, and others appear to have no comprehension about language, or at least spoken language, at all.

> Many forms of developmental delay and autism, as well as trauma and psychiatric problems with children, often prohibit or slow down normal development resulting in individuals who have not achieved the separation (from the primary caregiver necessary for individuation – the development of a more or less autonomous self) and live in a world of confusing objects in which they cannot find a place for themselves. By helping these children to develop their drawing skills towards the representational stage and beyond offers those individuals the opportunity to develop towards a sense of 'self'. Art therapy is therefore an appropriate and valid treatment in these areas. (Dubowski 1984, p.57)

Some severely disabled people may not develop language at all and as a consequence they have no words to understand their feelings. In such cases might it be possible that the marks they make in art therapy can begin to give some shape to these nameless emotions that can then be shared with another person? Art therapists are skilled in understanding not only the surface meaning of a picture, its manifest content, but also the feelings, thoughts and ideas that underlie or are below the conscious surface of the picture, the latent content. The expression of emotion through the medium of art can now be seen as offering the opportunity for the regulation and healing of personal emotional experience. One of the major themes we shall explore in this book is the quality of experience, shared with another person, that the autistic child might receive during art therapy.

Our theoretical understanding of developmental processes is diverse: objects relations theory and in particular the work of Donald Winnicott (1953, 1971, 1991) and Margaret Mahler (see Mahler, Pine and Bergman 1985) are influential, as is the more recent psychobiological work from authors such as Trevarthen (Trevarthen *et al.* 1998) and Schore (Schore 1999). In particular we shall draw on the work of Daniel Stern (1985) and his understanding of the importance of intersubjectivity in the infant–mother relationship.

It is important to make a distinction between the practice of psychotherapy or psychoanalysis and the understanding of developmental theories emanating from these disciplines. While we do not consider that our work as art therapists (with children who are autistic) is a form of psychotherapy in the way that the term is normally applied, we are very much influenced by the developmental theories mentioned above.

Throughout the book first-hand examples of work with children with autism are provided in order to familiarise readers with some of the characteristics of autism and how they manifest in the art therapy setting.

Notes

[1] TEACCH, standing for Treatment and Education of Autistic and Related Communication handicapped CHildren, was developed by the Department of Psychiatry, School of Medicine, University of North Carolina, USA. TEACCH is dedicated to improving the understanding and sevices available for all children and adults with autism and related communications handicaps. It is a comprehensive, community-based programme that includes consultation, research and professional training.

Makaton is a unique language programme offering a structured, multi-modal approach for the teaching of communication, language and literacy skills. The Makaton programme was devised by Margaret

Walker, a speech and language therapist working with children and adults with a variety of communication and learning difficulties. Makaton symbols and signs are matched to all concepts in the two vocabularies to be used with speech, the written word or on their own. The two vocabularies are a small nucleus of basic concepts essential to everyday life and a much larger open-ended topic-based resource vocabulary covering broader life experiences. Both provide a visual representation of language which increases understanding and makes expressive communication easier.

PECS, or the Picture Exchange Communication System, was developed as a unique augmentative alternative training package that allows children and adults with autism and other communication deficits to initiate communication. PECS begins with teaching a student to exchange a picture of a desired item with a teacher, who immediately honours the request. The system has been successful with adolescents and adults who have a wide array of communicative, cognitive physical difficulties (Bondy 1996).

Developmental Deficit
Communication and imagination

In this chapter we explore the nature of the deficits in both communication and imagination demonstrated in the behaviour of children with autism. All the examples are of children who have had art therapy with Kathy Evans.

Pre-therapy period

Before embarking on any therapy sessions, I made several visits to the children's school to allow the children to begin familiarising themselves with me, as a stranger.

Charlotte

Charlotte is 8 years old and has been attending individual art therapy sessions for the past eighteen months; this is our fortieth individual session together. I am now very familiar with her preferences for materials and I have prepared for the session by placing on the table five bottles of ready mixed paint – blue, red, yellow, green and white. Next to these I have placed a plastic palette in which I have put blocks of solid paint in the same colours. Brushes and a beaker of water together with a box of soft coloured pencils with a wide range of colours completes the selection of materials that I have made available. A range of different sized white paper is at hand. Within

moments of starting our session, Charlotte takes up the beaker of water and a brush, raises the beaker until her nose is on the lip of the beaker, barely brushing against it, while at the same time she stirs the water vigorously with the brush. All Charlotte's attention seems to be directed towards the sensation of the water; smell, touch and sound all feature in this. I am left feeling that she is totally unaware of my presence; still holding the beaker she has inclined herself away from me while we sit together at the table. I gently remind her that I am there by leaning forward towards her and calling her name; eventually she turns in my direction and notices that I am leaning on the sheet of paper between us, silently offering the surface of the paper to her. She takes the brush and makes repeated stroking movements over the paper; with only water on the brush there is no permanent mark but I notice the care that she takes not to allow the brush to go over the edges of the paper. At this point I offer her the palette containing the hard paints. Charlotte places the beaker of water onto the table and moves the palette closer to her self, lowering her face, smelling the paint and eventually getting so close that both her lips and her nose have traces of colour on them. I am left with the feeling that if uninterrupted, Charlotte will continue with this smelling and touching activity for the whole of the session.

Stephen

I first started working with Stephen when he was 7 years old. He had been diagnosed as autistic when he was 3; his behaviour on our first meeting struck me as very typical of autism. Even before we commenced therapy, we had become aware of each other within the school. I recall that on three separate occasions during the pre-therapy period, there had been some interactions between Stephen and myself, which (in retrospect) proved to be significant in indicating some of the consistent features of the art therapy that followed. This can be described in terms of an elaborate approach–retreat

sequence built up by Stephen. The sequence begins with Stephen peeking out from behind the curtain across the room from where I am sitting at a table. I become aware of him and we engage fleetingly in eye contact before he rapidly withdraws behind the curtain. I tentatively approach Stephen, taking with me a sheet of paper and some crayons, and arrange myself on the floor just in front of the curtain behind which he is hiding. I start to make some bold marks with the crayon; I am careful not to look up in the direction of Stephen, but I sense that he is watching me. After a few moments, taking my drawing and crayons with me, I return to my chair, leaving my drawing on the floor by the side of the table. Stephen's peeking from behind the curtain is repeated several times before he emerges and, avoiding all eye contact, he walks towards me and sits under the table hidden from my view.

With Stephen crouching underneath the table, I slowly lower my hand offering a crayon, which is accepted by him. Next I pass him a sheet of paper which he takes, and I can hear him working with the crayon under the table. After a short while I notice his palm open with the crayon resting on the table. I take this as a cue and change the crayon for a different colour. This is immediately accepted and his arm withdraws back to his hiding place underneath the table. This sequence is repeated several times over the course of the next ten minutes, at which point a member of the care staff draws to a close this particular school session and Stephen together with the other children are led away. It was not until this point that I was able to retrieve the drawing, the first image that Stephen had made with me. The drawing struck me as typical of what I would expect from a normally developing child of between 2 and 3 years old.

Eventually Stephen was referred to me and we completed thirty sessions together. Like Charlotte he did not use language though he would make loud exclamations, particularly when needing to demonstrate his dislike of certain things, usually people coming too close to

him. With me, I noticed that he was frequently very observant and watchful but in a covert way: I would glance up to find him staring straight at me, we would have fleeting eye contact, and then he would look away, burying his face in the curtains or covering it with his shoulder or arm. I felt that he wanted to interact but could not bring himself to dare to. Stephen's sensitivity towards other people (including myself) in terms of his use of personal space remained with us throughout the two years of therapy. Moving too close or too quickly into his space sometimes made him react quite violently; when this happened it took the form of him leaping towards me, beginning to grab my arms but immediately on contact letting go and retreating. On other occasions I would situate myself as far away in the therapy room as possible and avoid eye contact with him. After about five minutes he would quietly and slowly approach me, slip his arm around my shoulders and indicate that we could now start working together. Through these interactions and my observations of his reactions and behaviour, it became apparent that he sometimes enjoyed close interactions or even desired them with other people.

Although sensitive to his personal body space, he was also a very sensual child: he was very attracted to textures, running his hands delicately over different surfaces and materials, and to being touched on his own terms. For example within the ritual that I have described in which he would put his arms around my shoulders, it seemed to me that he was indicating that he wanted a cuddle. However, I had to observe his rules, which included not instigating or engaging eye contact or making any moves towards him. All interactions between us had to be governed by Stephen, who regulated them and further reinforced them by the way he would engage purposefully in eye contact on his terms.

Deficits in communication and imagination

What can be learned, from these two case examples, about the nature of deficit in communication and imagination typical of children with autism?

The term communication *deficit* suggests to us that there is something within the acquisition of communicative skills which has not properly developed. There are features within the interactions between the therapist and both Charlotte and Stephen which we consider demonstrate a particular communication *sensitivity* rather than deficit. If we explore some of the features evident in the behaviour of Charlotte and Stephen, we note that any comfortable approach or contact with the therapist is usually instigated by the child and conversely any instigation by the therapist to make such an approach or contact is frequently met with distress by the child. The work of Daniel Stern (1985) and others points to the importance of *reciprocity* between the infant and the primary caregiver and that this begins during the earliest stages of development. Does the evidence from the kinds of interactions typical of children with autism, as illustrated by both Charlotte and Stephen, suggest that there is something in the nature of the autistic condition that interferes with the capacity for reciprocity during the earliest stages of infancy? Later on we shall look in more detail at the work of Daniel Stern and others in an attempt to investigate this question further.

Turning to the area of *imagination,* what can be learned from Charlotte and Stephen? We can note an inappropriate use of the art materials that the therapist has made available. With Charlotte there is something about the tactile quality and smell of materials which is the point of fascination and she needs to be directly prompted by the therapist before beginning to use a brush as a mark-making implement. Even this can be seen to be inappropriate, as Charlotte has loaded the brush only with water and not with paint; the movements she makes over the surface of the sheet of paper leave no permanent

trace. In our experience this is not untypical: in other cases where children with autism have used paint, we have noticed that they do not attend to their mark-making activity, that is they look away from the sheet of paper rather than pay attention to the traces being left by the movement of the brush.

Although it might be noted that with Stephen, there is a more appropriate use of the crayons, the mark-making process takes place in isolation (under the table out of sight of the therapist). Stephen does not seem to have any interest in sharing his work with someone else; indeed at the end of the session, the drawing is left on the floor under the table as if it has no value. We consider this to be very typical and demonstrable in all of the children with autism we have worked with. There appears to be no sense of ownership of the completed drawings, nor do we see any sense of continuity or association between the different drawings that a child may produce over the course of the therapy. For example with another child, David, whose drawing skills had developed to a representational level (drawing recognisable objects) there was a great reluctance to look at or discuss drawings made in previous sessions.

With both Charlotte and Stephen, there was no evidence of the use of marks as a form of representation. These children did not name their scribbles or show any interest in imaginatively exploring possible meanings in their drawings in the way that we see in normally developing children, sometimes from as early as 2 years of age. Nor are the materials themselves used imaginatively, for example crayons are not held and moved through the air to represent a flying aeroplane or rocket. It is also worth noting that these children have been familiar with the properties of art materials for some time: both Stephen and Charlotte know the relationship between crayons and a sheet of paper. For Charlotte, however, the primary fascination with a crayon remains its smell, colour and texture. Again this is not untypical; a variant on this that we frequently observe is the autistic

child who systematically takes a nibble from every crayon in the box as if expecting each colour to have a different flavour. They do not seem to learn from this experience, as some children will repeat this tasting experiment week in, week out.

Symbolic thought

This kind of use of art materials is not only inappropriate but also highly unimaginative. Although this deficit of imagination has been noted as a feature of autism for many years, there is very little literature or research into *imagination* as such. While we acknowledge that research into theory of mind hypothesis (Baron-Cohen 1992) does inform us about certain aspects of the thinking process necessary for the development of imagination, it does not, in our opinion, offer a coherent theory of imagination as such.

It seems to us that a common element necessary for both communication and imagination is the capacity for symbolic thought. In communication the symbol has the function of being a vehicle of meaning passed between people. In imagination it is symbolic functioning that allows us to ascribe different meanings to the same objects: the banana can be a telephone receiver or a caterpillar or a boomerang, for example. Later on we shall look in detail at how normal children develop the capacity for symbolic thought and we shall speculate on how the condition of autism might interfere with these developmental processes. As art therapists it is important that we have some understanding of both communicative and imaginative processes. We acknowledge the importance of the therapeutic relationship and of the sharing of meaning and of emotion that takes place within this; this is of course a form of communication. Central to our work as art therapists is working with the image produced by our clients; the word image itself forms the first part of the word imagination. Can someone make an *image* without having first *imagination*? It is by understanding the developmental processes necessary

for the acquisition of symbolic functioning that we can offer an environment conducive to this development for our autistic clients.

Imaginative Play, Creativity and Art

We have commented on the importance of symbolic functioning to imaginative play and now we shall explore the relationship between this and the creative process and art. In this chapter we draw on theories developed mostly by Donald Winnicott (1971) about the development of symbolic thought in normal infants. Later in this chapter we shall discuss how the work of Frances Tustin (1981) into autistic object use might relate to Winnicott's model.

The biological dependency on a primary caregiver during the first years of life have led to the evolution of a symbiotic system of interdependence between infant and primary caregiver from which the child has to separate gradually. As infants develop they become increasingly autonomous. For example, by the time they begin to crawl they start to *play* with *separation* by literally creating a distance between themselves and their mother.

Transitional objects

This period is marked by some anxiety for the infant as the dependence on the primary caregiver is very necessary. In the actual absence of the primary caregiver, for example at bedtime, this anxiety becomes heightened. It is precisely at this point of development that most normally developing infants start to exhibit a particular attachment to some inanimate object, which might be a toy, blanket or a teddy bear. Winnicott referred to such objects as 'transitional objects',

marking as they do the transition from complete dependence to increasing independence. Such objects are also sometimes referred to as the first 'not me' objects as they start to stand in for or represent the absent mother. As such, these objects become the prototypical symbolic objects and also lay the foundations for the development of the capacity for symbolic thought.

From this theory we can see how symbols have a great potential for the alleviation of anxiety; they allow us to hold onto or anchor onto something of importance even when it is physically absent. Once anchored in this way, freed from anxiety, this freedom produces a space in which things can happen. This is both a physical space, the physical distance between the infant and the mother, and a psychological space, whereby infants now have a means of reassuring themselves that even in her physical absence their mother is there for them. This space is sometimes referred to as the 'potential space', potential for playful exploration of both the external material world and the inner world of feelings and ideas.

Signs and symbols

At this point we need to make an important distinction – that between symbols (in the way that these have been introduced already) and signs. Signs always stand for the same thing, whereas symbols have the power of representing many things at the same time. The *word* banana, when used as a sign, signals an item of fruit. Playing with a banana as if it were a telephone receiver is to use an object symbolically. The child knows it is a banana but is happy to pretend that it can also stand in for something else. This capacity for symbolic thinking, according to theorists such as Donald Winnicott, evolves directly from the first transitional object (Winnicott 1991).

Although many of the children with autism who we have worked with have developed language, we have noted that in many cases they use words only as signs rather than as symbols. Although they have

learned that certain words describe certain actions, physical objects and so on, they tend not to be able to use language metaphorically, and this seems to parallel the deficit in their capacity for symbolic play. As a consequence they are impoverished in any form of vocabulary for their complex inner feelings.

Comforting and holding infants

For all infants, before they develop ways of processing and understanding difficult experiences for themselves, they have to rely on the primary caregiver for soothing and for comfort. An infant might be woken by an extraneous loud noise that is experienced as invasive. Or it might be that the child is woken by stomach cramps experienced as internally invasive. Both kinds of experiences are distressing and result in the infant crying out. The attentive primary caregiver will recognise something of the meaning behind the cry and administer in a soothing and appropriate way, perhaps cuddling the child and rubbing the tummy while at the same time giving some words such as 'There, there, has baby got a bad tummy?'. If this form of administration and soothing is consistent then the baby learns to trust the relationship between cause and effect and in learning these lessons begins to master experiences that would otherwise cause great anxiety. Elgin summarises something of the experience of the infant during these early stages before the self has yet fully developed:

> Winnicott writes of unimaginable agonies that mark us before we can sustain, process or even experience them. We do not know what they are. They occur before we have frames of reference for them (if we ever do). Yet the unthinkable, unknown, perhaps unknowable agonies exert a pull. They leave intimations of breakdown at the origin of personality, agonising breakdowns that occur when personality is beginning to form. (Elgin 1998, p.17)

As we have seen during these early stages in development, infants have a very real need to be held both physically and emotionally by their primary caregiver. According to Winnicott (1971), this holding facilitates the infant's psychic development because it allows a pause from the raw experiencing in which learning to cope with anxieties can begin. It is through the process of projection that this can be better understood. The primary caregiver becomes a container for the infant's projected feelings and needs when she is ready and open to the infant's projections onto her. The child's distress as a result of the intrusion (as shown above) is as it were unprocessed anxiety. The primary caregiver's soothing and reassuring administrations can be seen as a form of processing the infant's raw feelings and then passing them back. As well as physically soothing and holding the infant, the primary caregiver also provides words; the tone and quality of her voice will be more important than the meaning behind the words to the infant but will also mark the infant's introduction to the world of language. Mahler reminds us of this:

> The archaic common language of human beings is and remains the language of affect. Whenever the repressed complexes of childhood are evoked, we relapse again into this unconscious affective rapport. (Mahler, Pine and Bergman 1985, p.4)

Transitional stage

We shall discuss the importance of the primary caregiver–infant relationship later when we look at the work of Daniel Stern, but at this point we need to return to Winnicott's 'transitional stage' and the use of transitional objects. According to Winnicott's formulation (as we have seen), it is this transitional stage that gives rise to a potential space in which imaginative play and a capacity for symbolisation arise.

Frances Tustin in describing her work with autistic children commented on their use of toys and other objects and the differences that she noticed from the way that normal children use transitional objects. For example, one child came to all her sessions holding a small toy metal car in his hand. Initially this child's relationship with the toy seemed no different from what is commonly seen in all children with their transitional objects. Over the course of many sessions, however, Tustin noticed that it was not always the same toy car that the child brought. (Any mother knows that during this transitional stage, taking away the actual transitional object will be met with disastrous consequences and that such objects cannot be replaced by anything else.) Another anomaly noted by Tustin was with an inappropriate use of the toy car itself. The child did not play with it but held it in his hand with such force that the form of the car left an impression on his hand. Because of these factors, Tustin coined the term 'autistic object'. If in the cases of autism the transitional object becomes or is replaced by the 'autistic object', does it follow that the qualities of the transitional space, the capacity to fill the 'potential space' with imaginative play, is denied?

This crucial stage of development, leading to the beginnings of the capacity for symbolisation, also lays the foundation for the communicative skills necessary for later social relations. Might it be that one of the reasons why it remains difficult to diagnose autism in children under the age of 3 is because such a diagnosis is based on looking for deficits in communication, socialisation and imagination? Whether it is that the complexities associated with the development during this 'transitional stage' give rise to autistic symptoms, or that the symptoms have not yet been pronounced enough to be recognised until this stage is not at issue here (Tustin's distinction between psychogenic or organic forms of autism may be useful in this respect).

It does seem clear to us that children with autism do not pass through these stages as described by Winnicott in a normal way. For

whatever reason(s) this may be, we would argue that the deficits in communication, socialisation and imagination largely stem from this inability to move through these stages. This has become a first principle for us in our practice; later on we shall show how the methods we employ are largely based on normal stages of development that precede the transitional stage. In order to have a better understanding of those stages we now turn to look at the work of Daniel Stern.

Senses of self

We have stressed the importance of the infant–primary caregiver relationship and have shown that these interchanges are essentially reciprocal and contribute to the infant's development of self. Daniel Stern (1985) places the infant's emerging sense of self and sense of other at the centre of early infant experience and describes it as profoundly influencing all future social experiences. He considers that several *senses of self* exist in pre-verbal form before the development of self-awareness and language. He assumes that some of these pre-verbal senses of self start at birth or even possibly before. These 'senses of self' form the foundation for the subjective experience of social development:

> Development occurs in leaps and bounds; qualitative shifts may be one of its many obvious features…integrations arrive in quantum leaps and between these periods of rapid change are periods of relative quiescence when the new integrations appear to consolidate. (Stern 1985, p.8)

Stern describes four stages that occur from birth to approximately 15 months of age. The first of these, beginning at birth and lasting for the first eight weeks or so, is marked by the infant's inability to distinguish between the experience of its perceptions and itself as the receiver of those perceptions. In other words, infants experience

sound, sight, smell, touch and taste and in processing these sensory inputs, they begin to experience a separation between the raw sensory input and themselves as the processor of that input. Accordingly Stern refers to this stage as *the sense of an emergent self.*

This domain of the emergent self acts as a source for perceptual evaluation and remains active during the formative period of each of the subsequent domains of senses of self. The later senses of self are 'forms' which have emerged from the organisational processes of this initial emerging sense of self. This ability to differentiate between sensations and oneself as the processor of those sensations allows infants to begin to experience themselves as 'separate, cohesive, bounded, physical' with a sense of their own agency, effectively and continually in time (Stern 1985). This stage, which occurs between the ages of 2 and 6 months, is described as the sense of a *core self.*

Between 7 and 15 months infants become increasingly aware that the primary caregiver and other people have the capacity to sense their state of experience and feelings. Infants learn that they can share the 'contents of [their] mind and the quality of [their] feelings' (p.124) with another. Stern refers to this as the sense of a *subjective self.* At about this time with the onset of language, infants are developing the capacities for the explicit sharing and communicating their experience with others and Stern refers to this as the sense of the *verbal self.*

In comparing Winnicott and Stern's two models, we can see that Winnicott's 'transitional' stage has some parallels with Stern's sense of a 'core self':

> Self-regulating experiences with things that have become personified can also occur at this age and level of relatedness (2–6 months). Such events fall at an early point on the developmental line that later includes transitional objects (like security blankets, which stand for and can be freely substituted for persons) and even later the larger realm of transi-

tional phenomena embracing the worlds of art, as Winnicott (1971) has taught us. (Stern 1985, p.122)

Verbalisation and social interaction

So let us explore some of the behaviour of children during their second year of life. The precursors for later imaginative play can clearly be seen to be present. It is not much later before a normal child's play with objects is accompanied with verbalisations. For example, a little girl of 20 months ran around the nursery room saying 'let's drawing' to the other children and then made some scribbles naming them 'butterfly', 'mummy', 'house'. This activity received an encouraging response from the carers of the nursery session, indicating the importance of reciprocity of social interaction during this stage of development. In contrast the play often exhibited by children with autism is solitary, rigid and inflexible.

Work by authors such as Daniel Stern shows just how marvellously complicated the human infant is. The infant's mind is far more active than hitherto imagined and even before he or she develops formal ways of communicating this (such as language), non-verbal communication is taking place at a highly complex level. It is important for us to understand the nature of these complexities, such as the later development of drawing. This is because we now know that children potentially have a lot to say before they have the ability to say it. By the time the child has developed a sense of 'subjective self' he or she has also developed enough hand–eye coordination to begin experimenting with drawing; it is this line of development that we shall explore in Chapter 3.

Drawing Development

Children do not need any art materials in order to start to develop their drawing skills. This might sound like a rather bold statement, but in our experience it is exactly the case. The world is full of opportunities to explore mark-making behaviour just waiting to be discovered by the curious and inquisitive child.

Jason

Jason at the age of approximately 14 months was being fed his favourite pudding of pureed apples and custard and as usual a fair amount of the mixture landed on the table and floor. Jason could not resist the bright yellow spillage that was within his reach and in no time his hand was in it experimenting not only with texture but also with the changing shape of the spillage as his hand moved through it. We can observe that for Jason this was a totally sensory experience that incorporates taste, smell, touch, texture and vision. We can add to that oral stimulation if we take into account his vocalisation of delight when handling this exciting material. In moving his fingers through the substance on the table, Jason became aware that different movements of his fingers resulted in different kinds of marks and shapes. Such a novel discovery prompted him towards further experimentation and other surfaces such as a misted pane of glass in a window afforded further opportunities for his exploration of drawing.

Drawing and language development

Children's drawing development starts at about the same time as language begins to develop, at around the age of 15 months. The onset of drawing and language indicates a major shift in the child's development – a point when there is a need for a more sophisticated 'means' by which it is possible to express their experience and thoughts, and communicate these 'explicitly' to others.

Pre-representational drawing

A term often employed to describe these early primitive marks made by children is 'scribble'. We have learned to understand this term to describe something which is considered meaningless. As we shall show, this is far from the case, even at these early developmental stages. We prefer to use the term 'pre-representational' drawing development and this term requires some definitions. The term 'representational' refers literally to re-presenting something, when related to drawing, a visual something. On one level this might indicate an actual visual stimulus: I have seen a flower in the garden, and in its absence, I can re-present it by drawing it. On a different level I can use drawing in order to re-present aspects of the inner world, my anger or my disappointment can be re-presented, on an abstract level through the use of colour and form. By using the term pre-representational we are indicating that during the earlier stages of the developmental process the child does not necessarily have a conscious intention to represent anything. As in the example of Jason, the sheer enjoyment and pleasure gained from the novel experience of realising that a movement of the hand results in a change of form is the main motivating factor.

Through a process of playful experimentation, the child soon learns that different kinds of movements result in different kinds of marks; in effect, the child is beginning to develop a kind of 'vocabu-

lary' of marks. Later on, a combination of these different marks will be employed in order to create re-presentational drawings, a conscious intention of taking an internal mental image, idea, thought or feeling, and translating this into the drawing in order to share this with another. In this way, we can see that drawing in many respects mirrors language; they are both formal means of communication. There are a number of stages to be negotiated between the earliest stage of pre-representational mark-making and the capacity for representational drawing.

Mark-making stages

Drawing development has been studied by psychologists and philosophers since at least the end of the nineteenth century. We begin by looking at the work of Victor Lowenfeld (Lowenfeld and Brittain 1987). Lowenfeld stressed the role of the expressive arts in general development, especially in the social and emotional adjustment of the child. He describes early mark-making as the 'scribble stage' that lasts from 2 to 4 years of age; mark-making behaviour is largely motivated by the physical activity that it involves. Lowenfeld points out that at this stage the mark-making will sometimes be accompanied by a verbal description of what is going on and that this is not necessarily directed at anyone in particular but often seems to be a communication with the 'self'. This stage is often referred to as 'named scribble'. Although not all children do this, Lowenfield remarks that it seems apparent that drawing now becomes a record of how children feel about aspects of their environment. Aspects of our research as art therapists involves the observation of children as they move through these various developmental stages. In order to analyse these in detail we frequently employ video-recording.

Patrick

Patrick was observed when he was approximately 2 years of age, and remarkably, the video-recording revealed that he spent a total of forty-five minutes engaged in the creation of a single drawing (see Figure 3.1). Although the finished work lacks any recognisable form (and therefore might be regarded, in Lowenfeld's terms, as a pre-representational *scribble*) the video-recording clearly indicated relationships between Patrick's interactions with the environment and the marks that he made. Patrick was aware of the video equipment and said 'camera' while at the same time using yellow crayons with small multiple vertical movements. A little later on his attention turned to looking around the room and his eyes settled on a poster that featured images of fishes; at this point he selected a brown crayon, his drawing movements changed to larger circular movements and he said the word 'fish'. Still holding the same brown crayon, Patrick's attention

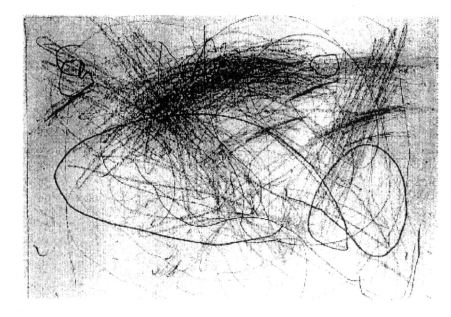

Figure 3.1 Patrick's consolidated drawing

now turned to the other children sitting close to him at the table and although he was not looking at what he was doing, his hand continued to make marks that are clearly visible towards the bottom of the sheet of paper. Patrick continued to explore different colours and different movements of the implement until the rather complex drawing was completed. Here we have an example of 'named scribble' accompanied by physical activity as described by Lowenfeld.

Pre-schematic stage

By the age of 4 Lowenfield notes that children begin to make recognisable drawings; this is referred to as the pre-schematic stage. At this point the child 'connects the marks to the world around them…the lines become more than…the result of motion, become the edge of a form' (Lowenfeld and Brittain 1987, p.253).

This stage of development was first identified by Lucquet (1929), who referred to it as 'fortuitous realism', which he described as 'the child discovering the meaning of the drawing in the act of making it' (Lucquet 1929, p.155). It is during the earlier scribble stage that children experiment with different movements of the implement in their hand, noting the different marks that result. The novelty of this activity catches and holds the child's fascination and attention (as was obvious in the example of Patrick). According to Lucquet, a point is reached where children recognise a form within the marks they have produced even though there was no prior intention for representation. Perhaps one of the simplest examples of this would be of the child exploring circular movements of the wrist and stumbling upon drawing a joined-up circle.

One of the qualities of the circle is that it encloses a form. In Gestalt terms the circle on the blank sheet of paper has both the figure and the ground. To the child's imagination this form might represent almost anything, a person, a motor car or animal, for example. This

stage of development marks the transition between pre-representational and representational drawing.

Schematic stage

In discovering that marks have the potential to resemble objects in the real world, the child also discovers that art is a form of language. Returning to Lowenfeld, this is followed by what he termed the schematic stage of drawing development. For example, a child who discovers the circle by making a clockwise movement of the wrist may experiment with this movement in order to master it. Although it is possible, as we know, to draw a circle either clockwise or anti-clockwise, this does not occur to the child. In sticking to making the mark only in the way that he or she has learned, the child is using mark-making in a schematic way. Such schemata become increasingly complex; the most common one to be observed is frequently referred to as the tadpole person. This familiar figure usually consists of a circle with smaller marks placed inside of it, representing facial features, and four lines radiating out from the circumference representing the arms and legs. In our observations of children at this stage of development we note that in the majority of cases the sequence of marks used in constructing this figure is rigidly adhered to.

Geoffrey

Geoffrey spontaneously produced a circle with two smaller marks within it and the four radiating limbs. I asked him to tell me about elements of the drawing by pointing to the marks inside the circle and he told me that they were eyes. I asked 'Where is the nose?' and his first reaction was to touch his own nose, after which a third mark was placed inside the circle. When working with him a week later, he again drew a figure but this time on completing the circle, the two internal marks and the four radiating lines, he placed the third mark

into the circle and was delighted to tell me yet again that this was a nose. We continued with the game and I asked him about the mouth; again he put his hand to his own mouth before placing a fourth mark into the circle. Here we can see the term 'schema' is used to describe a rigid formulaic means of attaining a representation in drawing; it can be repeated again and again with the security of knowing that one will attain the same result. Another term associated with this stage of development is 'intellectual realism' (as opposed to visual realism).

Intellectual realism stage

In Lucquet's (1929) terms, during the intellectual realism stage of drawing development, children draw what they know rather than what they see. Children's drawings depend on what they have in mind rather than what they see in front of them. To take Geoffrey's work a little later on, he was drawing two circles one above the other, the first depicting the head, the second the body. On this occasion I asked him 'Where is the belly button?' and he immediately put his hand to his tummy before making a mark within the second lower circle. It is clear that he was not feeling or looking at the whole figure, but was relying on his internal knowledge about his own anatomy in exploring where to place a mark that would represent a 'belly button'; he drew what he knew about himself.

By this stage the child not only knows that drawing can be a form of language but also has begun to develop a vocabulary of that language. The more that children play and experiment with line, form and colour, the more competent they become in translating their internal image onto the sheet of paper. Soon they become so proficient that there is almost nothing that they perceive that they cannot express. Their drawings become inhabited by people, animals, trees, flowers, houses and motor cars, in short their experience of the world. Children's drawings become re-presentations of their experience.

Respresentation and symbolisation

At this point we need to explore the relationship between the capacity for representation as we have just outlined it and the capacity for symbolisation as described in Chapter 2. In terms of chronological development it is easy to superimpose Winnicott's model, the potential space afforded by the discovery of the transitional object, to the development of play and of art as a form of play. Children have already had an experience of symbolic thought through the use of their transitional object even before they have developed enough hand–eye coordination to begin experimenting with mark-making. Accordingly they are already equipped to discover meaning in the traces that they create as they draw even though they do not begin with a conscious intention to represent.

In Chapter 4 we shall explore how the condition of autism and its associated symptoms affect the child's negotiation of these developmental stages and how this might be recognised, and the art work produced by children with autism.

Symbols, Signs, Theory of Mind, Autism and Drawing Development

Within the autistic spectrum, there may be children for whom the onset of the condition occurs after the age of 3 years. For many others the onset will have occurred much earlier and the symptoms associated with onset may interfere with those stages of development as described by authors such as Donald Winnicott and Daniel Stern. If some children have a genetic predisposition for the condition, it may be that autism is something that they are born with. Most of the diagnostic instruments for autism are not effective with children under the age of 3 and it is very unusual for pre-school children to be referred for art therapy.

It is our view that an understanding of those earlier stages of development leading to the capacity for symbolisation is essential if we are to understand something about the art made by children with autism. By the time that we typically see children with autism who are referred to us for art therapy, they will have already passed through these important developmental stages but will have also developed in varying degrees a range of symptoms associated with their autism. One of our important initial tasks is to attempt to untangle the symptoms from the developmental milestones.

David

David began art therapy when he was 9 years old and had been diagnosed as autistic when he was 4, although it was recorded that his parents had recognised that there was something wrong much earlier. Because the majority of children with autism show signs of distress in the presence of strangers, it is my practice to spend some time in their environment before formally beginning therapy. This provides the opportunity for the children to begin getting used to me and me to them.

My first impressions of David was that in many respects he had the delicate features and translucent skin often found in children with autism. My first encounter with him was during an evening recreational session in which art activities featured. I noted that in his use of the art materials, he demonstrated good perceptual, motor and discrimination skills. He seemed to enjoy art making very much ; he was engrossed in the activity, pausing from time to time from his drawing to utter one or two words, usually describing what he had drawn but not directed to any particular other person. Over a six-week familiarisation period I had the opportunity of discussing David's art work with other staff members. He was regarded as being very good at art but that he had an obsession with drawing animals, something that he had been doing (it was reported) since he was an infant. Any attempt to encourage him to draw anything other than animals had proved unsuccessful.

Of course different children have different levels of sensitivity to strangers or strange situations and it is therefore not easy to suggest how long a period of familiarisation should last. I would suggest, on the basis of seeing the child once a week, that a minimum of four such sessions should take place before the formal therapy begins; with some children a much longer period may be necessary.

With David it was not until the third familiarisation session that I felt it appropriate to approach him physically. I sat down close to him

and although my approach was not met by any evidence of distress, he did not seek my attention. My attempts to start a conversation with him were met with a blankness; he turned his face towards me without making eye contact, looking past me or through me. With David this period of familiarisation lasted six weeks; during weeks 5 and 6 I began to broach the idea of him working with me in the art therapy room. However, in spite of these lengthy familiarisation sessions, our first formal session still proved very difficult.

The structure of the ensuing art therapy sessions was largely based on my early observations. I had an idea of David's concentration span and decided that weekly sessions of just half an hour would be appropriate. I had also become familiar with his preferred art materials and for the initial session I had available a limited selection of pencil crayons and large sheets (A3 size) of paper. Another feature of the therapy room was the video camera, as it is my practice to record at least the initial sessions of therapy.

At the beginning of the session David seemed relatively relaxed. With the familiar materials in front of him, he settled at the table and began drawing. With his right hand he leant over his sheet of paper, using his left arm resting over the top of his drawing to shield what he was doing from me. His images were absolutely typical of what I had already seen, i.e. outline drawings of a variety of animals, in this first drawing a lion, tiger and dog. On completing each figure he paused, leant back but without looking towards me, and named the animal he had just drawn. I had positioned myself on his left side sitting about a yard from him, close enough to be aware of his activity without being too close and risking distressing him. Sensing that David had completed his first drawing, I offered him another sheet of paper which he accepted and, adopting the same pose, he began to draw again.

The second drawing was again typical, featuring more animals, with short pauses during which he named what he had drawn. I was

very aware, in observing the construction of these animal drawings, that his drawing style was very schematic. David was very familiar and comfortable with the formula he had developed to construct these drawings and I felt that the repetitive way in which he constructed these animals was very similar to other kinds of repetitive behaviour symptomatic of autism. It was at this point that I decided to suggest something new. Shortly after he accepted a third sheet of paper from me, he began to construct another schematic animal drawing; at this point I interrupted him and asked whether he might draw an image of himself for me. My request initially caused him to pause and to look up, move his head away from me as if he was looking into the far distance in the corner of the room, then he seemed ready to begin drawing. The first thing that he did was to write his name and then he paused as if he felt that he had complied with my request. I acknowledged that he had written his name but repeated that I would like him to make a drawing of himself. David then began by drawing an enclosed outline delineating a head; without taking his pencil off the paper, he included shapes for ears within the outline. He then scribbled across the top of the head indicating hair. At this point I sensed that David was becoming anxious; he leant and took a pause in his drawing and then started again on the same sheet of paper with another outline of a head, drawing again in a clockwise direction but stopping before closing the circle. During the ensuing pause I again sensed his anxiety; this time he turned towards me without making eye contact but in a way that suggested to me that he was in need of some reassurance. His distress increased and he screwed up his drawing, moving his right hand towards his mouth. I thought that he was about to bite himself but although his hand was well into his mouth, he managed enough self-control not to harm himself. I carefully removed the now screwed-up drawing; placing it to one side, I told David that he need not continue with this if he did not want to and that he could have a clean sheet of paper. This

appeared to calm him; he took up his crayons again and resumed drawing his very familiar schematic animals. During this first half-hour session, David produced a total of seven drawings, mostly featuring animals. Towards the end of the session, David asked me to draw with him by instructing me 'Draw tiger'. We worked together for a while; by the end of the session, David seemed calm and relaxed.

This situation made me very aware of his sensitivity about understanding language. Most people who know and care for David ensure that he experiences as little distress as possible in this respect. In the first session of art therapy, I did not continue this role, which resulted in his distress. However, now that I had an understanding about the nature of his difficulties, I was able to pay more attention and sensitivity in my use of language with him. Our relationship developed quickly; by the second session he was more comfortable with me and in his way he was telling me not to talk. For example he would say 'That's enough Kathy' when I talked to him. As our relationship developed, we increasingly relied on non-verbal communication, much of which can be seen in the video-recording. Our bodies, hand and head movements can be seen rhythmically related one to the other as we become attuned to each other.

As our relationship developed and David became more comfortable with me, his distress diminished; by the ninth session he was tolerant of my verbal interactions. David also became more able to cope with new situations presented in the sessions. In session 28, for example, I was able to encourage him to continue work on an image which he had begun during a previous session. During our earlier work together, David had been very reluctant to return to any work which he had previously completed, insisting on beginning with a new sheet of paper. Although on the face of it these small changes may appear insignificant, they can inform us about important developmental shifts. For example, in returning to an image begun a week previously, David was beginning to make a form of narrative relation-

ship between the past and the present. We can understand more from a developmental perspective through analysing the actual drawings made by David and by the processes that led to the production of those drawings.

David's drawings of animals are competently executed and meticulously drawn as we can see in Figures 4.1 and 4.2. Over the time that I worked with him, he depicted a large number of different animals including elephants, tigers, monkeys, cows and spiders, naming each in turn. However, in analysing the production of these drawings through both direct observation and analysing video tape, it becomes clear that they are all drawn using the same basic formula. The range of different marks used in the execution of each drawing is very limited: all of the drawings have a 'flat' appearance with no attempt at shading or using colour to depict three-dimensionality. The rigidity of his drawing process contrasts with the competence of the finished drawings themselves. In many respects we consider this form of drawing to be no different from other forms of repetitive behaviour noted in children with autism, such as the rigid stacking of building

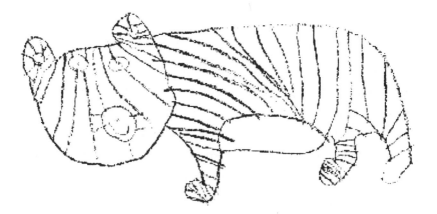

Figure 4.1 David's tiger

blocks or the lining up of crayons in strict colour order. Now we can see that what at first glance might have appeared to be a meticulous and competent drawing is in fact a symptom of the child's autistic condition. We can also comment that the formulaic and rigid production and naming of these animal drawings, within the art therapy situation, are in themselves ways in which David is attempting to alleviate the anxiety and distress caused to him by being in a novel situation with a new therapist.

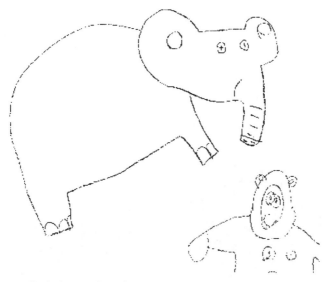

Figure 4.2 David's elephant and monkey

As the therapist gradually attunes to the client, we see a diminishing of anxiety and distress, allowing for the gradual development of the therapeutic relationship. In sensitively monitoring this, the therapist can now introduce new and novel experiences into the therapy situation. In David's case we had to consider the developmental stage related to his typical animal drawings. The drawings were schematic and representational, typical of the drawings of ordinary 7 year olds. However, whereas ordinary 7-year-old children frequently exhibit an emotional relationship with what they are drawing, frequently ac-

companied by a rich narrative, this was lacking in David. In his naming of the animals, there was no indication of any particular preference or relationship or excitement or any other emotional response. This suggested to us that he has perhaps missed some of the earlier stages of drawing development during which a playful experimentation with a range of art materials triggers a direct emotional response in the child.

Our strategy was to attempt to provide David with the opportunity for a more playful experimentation with art materials and to avoid situations in which he needed to resort to the more rigid stereotyped and typical drawings. Paradoxically it was the introduction of novel materials that caused the anxiety that he wanted to alleviate by returning to his known and familiar formulaic animal drawings. Over the weeks David did become far more adventurous with his use of art materials: his pencil crayons were replaced with paint and brushes

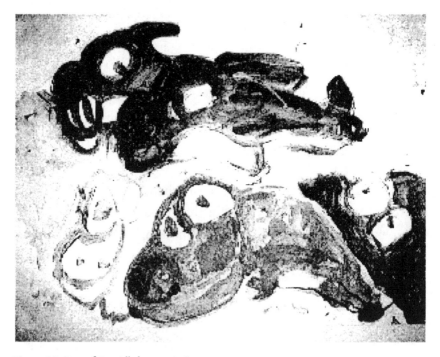

Figure 4.3 One of David's later paintings

and he was able to work on a much larger scale than before. On closer inspection, many of these later paintings can be seen to incorporate some of the more rigid animal drawings underneath the paint (Figure 4.3).

Reflection on the progression of his engagement in art making, together with the art work produced, indicated that he retained his schematic formula for drawing in his approach to the activity; this suggested that although he had built up a tolerance to new experiences in art therapy, his need for his safety net remained. In his acknowledgement of the importance of retaining his coping strategy, and the therapist's acceptance of this, David also gained a greater insight and understanding of his autism.

Interactive art therapy

The cases that we have provided can serve as examples of the particular methodology of art therapy that we have developed in our work with autistic children. In developing the characteristics of this methodology, we have used the term 'interactive art therapy' because of the emphasis we place on careful observation of the totality of both the child's and therapist's experience within the therapeutic framework. This model specifically addresses the development of communicative abilities of children with autistic spectrum disorder but at this point it is important that we underline yet again our definition of communication. Our concern, for example, is not just with language as a form of communication but also with the totality of the communicative framework that emerges from the moment of birth as shown and described previously by authors such as Daniel Stern and Donald Winnicott.

The Basis for Intervention
From theory to practice

The emerging communicative patterns that culminate in the develop-
ment of more sophisticated modes such as language and representa-
tional art have their origins during the earliest stages of life. For some
children with autism, the symptoms of the disorder may affect these
earliest communicative strategies in such a way that the later
emergence of language is severely blocked. We have explored the re-
lationship between verbal language and other forms of communica-
tion, particularly communication through art. It is therefore clear to
us that in such cases, early therapeutic intervention would be benefi-
cial. Indeed, equipped with an understanding of these developmental
processes, the therapist can make potent interventions with an autistic
infant or child while the individual is actually going through that de-
velopmental process.

A point that is worth repeating is that art therapy can be applied to
children as early as 12–18 months old. As new diagnostic instru-
ments develop, making it easier to detect autism at a much earlier age,
art therapists will have greater opportunities to make early interven-
tions.

Reciprocal cueing

An interactive approach based on theories of infant–caregiver inter-
actions in very early infancy has been shown to be effective in estab-

lishing a first good contact with children with autism, providing a basis from which the possibilities of developing a therapeutic relationship can be developed. Therapeutic interventions within this model include 'reciprocal cueing', a term introduced by Brazelton to describe mother–infant interactions in which each seeks a response from the other (see Brazelton, Koslowski and Main 1974). In much the same way that both mother and infant are actively seeking cues from each other, the therapist needs to be aware that even the most severely affected child with autism may nevertheless be 'cueing' in barely perceptible ways for some communicative contact.

Many of these types of interactions are so subtle that even the most experienced therapist may fail to recognise them. It is not until after a session which has been video-recorded that we are able to see the nature of the child's responses. For example, during a second session with one child, many of the interactive responses seemed to be related to the avoidance of contact or proximity with the therapist. Looking towards or at the child was met with averted gaze and any physical movement towards the child was met with the child moving away. In analysing the video-recording, however, it is clear to see that the 'moving away' on the part of the child exactly follows or 'mirrors' the therapist's movements. Once the pattern of this form of interaction is recognised by the therapist (usually following a micro-analysis of video-recording) such elements of 'reciprical cueing' can be incorporated into the therapeutic relationship and built upon in future sessions.

Protoconversation

Following on from this, we focus on Trevarthen's concept of 'protoconversation' ('motherese') (Trevarthen and Neisser 1993), in which it is the mother's response to the baby's utterances that gives them meaning. In the art therapy situation, the therapist focuses on all aspects of the child's expression and attempts both to understand and

feed back that understanding to the child. Put another way we would consider that any expression made by an individual, such as a vocalisation or an action, is in direct response to the individual's environment, including other people within it. The therapist's responses to such expressions are designed to help the child to find some shape or form for meaning concerning the nature of such expressions.

Charlotte

Charlotte has not spoken at all in any of our fifty sessions so far but hums and vocalises to herself frequently. Sometimes she makes high-pitch staccato sounds while looking towards the ceiling and moving her eyes around as if to see where the sound is going. By following her gaze and echoing her high-pitch vocalisations, I enter Charlotte's world, and in sharing her experience, give significance to it. This has greatly contributed to our ongoing interactions to the point that Charlotte now actively seeks to share experience with me. Although spoken language is still not used, the quality of our 'protoconversation' is now reciprocal and relaxed.

During a particular session, I became aware of the soporific effect of our interactions, an incredible sleepiness that came over me and the difficulties I had in not drifting off to sleep. I became aware at this point that Charlotte had moved closer to me and that the quality of our eye contact had increased considerably. This had the effect of making me feel as if Charlotte was needing to keep in closeness to me and was actively seeking my full attention. This was a turning point in our art therapy, during which a fuller therapeutic relationship was established. I was able, non-verbally, to let Charlotte know that I understood her need for contact and closeness, I acknowledged her need and want to be in relation with me and this acknowledgement proved to be very valuable to her. Of interest were the four paintings that she produced during this session (see Figures 5.1, 5.2, 5.3 and 5.4)

depicting closeness, isolation and images that I consider reflect her understanding of the empathic attunement between us.

Figure 5.1 Charlotte's painting 1

Figure 5.2 Charlotte's painting 2

Figure 5.3 Charlotte's painting 3

Figure 5.4 Charlotte's painting 4

Attention and sensitivity

Winnicott (1953) and Bowlby (1965) stressed the importance of sensitivity and unconditional loving in the infant–caregiver relationship. These are the conditions for providing the infant with focused attention in a secure environment necessary for the establishment for the foundations of communicative skills. Within the therapeutic situation, undivided attention and sensitivity are essential for the foundations of a therapeutic relationship. Such a relationship between both client and therapist provides opportunities for empathic attunement.

Rhythm and body language

Condon and Sander (1974) focus on an awareness of rhythm and body language: this is an important aspect of both the mother–infant bond and the interactive relationship between therapist and client. Returning to our work with David during our second session together (see Chapter 4), we have described the difficulties that the therapist had in picking up an awareness of his non-verbal body language. It was not until after the session, when analysing the video-recording, that the rhythms of his movements became recognisable. During subsequent sessions it became far easier for the therapist to attune to the communicative properties of these interactions resulting in the alleviating of the mutual tension.

Early infant experiences

All of these forms of interactions occur naturally and form an intrinsic part of the social environment; they are present within all social interactions including within the therapeutic space. Working within the paradigm of 'intersubjectivity' also requires a re-evaluation of how we understand what occurs within the client–therapist relationship as

it is often considered to reflect much earlier important relationships that the client has had with significant persons in his or her life.

Fundamentally, in Stern's (1985) view early infant experience is concerned with 'reality', i.e. events that actually happen, and this is not distorted for 'defensive' reasons. For example the 'phenomena' thought by psychoanalytic theory to play a crucial role in very early development, such as delusions of merger or fusion, Stern (1985) regarded as not applicable to early infancy, before the age of approximately 18–24 months. He considered that this is conceivable only after the 'capacity for symbolisation' appeared as evidenced by language when infancy ends. Stern (1985) suggested that this view has important clinical implications as it questions the psychotherapeutic method of reconstructing a client's past and suggests that psychoanalysis is better able to describe development after infancy is over and the capacity to symbolise is available. He suggests as an alternative that, when reconstructing the patient's history, the use of developmental theory to locate the origins of pathology in one of the domains of 'self' experience would indicate the pathway the patient's development has followed.

The work of Marijke Rutten-Saris (1990) has been found to be effective in connection with individuals with learning disabilities and autism (see Sandle 1998). Marijke was one of the first art therapists to base their interventions on Daniel Stern's work; subsequently she has collaborated extensively with Kathy Evans. In order to re-emphasise the value of Stern's description of 'vitality affects' as a basis for a way of working with the kinds of experiences that art therapists encounter in sessions with autistic clients, their views are re-presented here.

Any model of art therapy based on an understanding of human development, designed to provide interventions that can help individuals to develop to their maximum potential, must take into account the relationship between perception and the environment and how these perceptions can be re-presented through art. Our relationship with

our environment begins as soon as we are born: Stern (1985) describes how our early infant sensory awareness of the world and our environment is by way of changes in sensation, what he refers to as an 'activation contour' in which existence, experience and activities occur in time simultaneously. The infant's experience is of a buzzing world, an undefined 'IT', which Stern describes as 'amodal information'.

As the infant develops, this amorphous information becomes characterised by recurring rhythms; certain sensory features become more defined and apparent. During this stage the defined features are not necessarily sense exclusive, the infant does not attempt to organise what is seen as distinct from what is heard, for example. Perception is 'cross-modal', a synaesthetic interaction among the senses, where qualitative dimensions can share sensory modes; for example changes in intensity involve things getting both louder and brighter, and where sound and vision have an equal interactive commonality in defining such a sensory change. This emergence of cross-modal perceived features are called vitality affects by Stern, which then transpose easily into 'categorical affects', felt patterns of feelings, such as sadness, happiness, surprise, and so on. The categorical affects and their emerging Gestalts (recurring whole forms) become basic sensations and feelings to be further identified by signs and words and eventually language.

Before refinement and at the level of vitality affects, virtual feelings can be produced from others or other things, so that for example in the presence of somebody else we can 'feel' if someone is very excited or sad without verbal exchange. At this experiential stage, these are yet to be described explicitly as categorical affects. This process is dependent not only on conventional non-verbal communication but also on the way our senses can cross-modally interact and upon our sensitivity to cross-sensory analogies and metaphors (as exemplified in poetic and expressive language, where we might

describe someone with a loud tie, or who is seen as green with envy, or speaks with a bright voice).

We find Stern's description of an 'activation contour', 'vitality affects', 'categorical affects' and 'amodal and cross-perception' useful when relating these to the kind of experience an individual could have in art therapy when coming into contact with art materials. The art medium forms part of the individual's perceived environment and radiates its particular qualities such as the wetness of paint or the dryness of chalk. Everything that occurs during the art therapy session radiates its own vitality effect; the actions of the therapists, their movement in the room as they interact with the children, the sounds they make and the words they use and even their mood are intimately involved in emerging expressive and cognitive communication. As such, communication does not reside just within the finished pictures made by the child, but within the emerging and shifting dynamics of the whole art therapy process and its context. The means which enable this dynamic to be perceived, recognised and developed by the therapist's interventions are located on the one hand within the notion of 'vitality affects' and 'categorical affects' and on the other within the cognitive-developmental aspects of drawing and image making.

We have highlighted the kinds of behaviour patterns reflecting the kind of human contact and communication which are based on sensory intersubjectivity. These patterns of behaviour are non-verbal and contribute to the sensitivity we all have towards other people in terms of body space, rhythm, touch, distance and retreat relatedness. We have incorporated much of this thinking into our assessment framework and model of art therapy as described in the following chapters. But before we do so we need first to explore how we understand the relationship between this early predominately sensory experience and the pre-representational drawing development that parallels it.

The experience of art making in infancy

In early infancy the development of art-making skills is part of the evolution of general development. As we have seen, the infant's experience at this very early stage is complex, experiential and sensorily cross-modal.

An understanding of the developmental processes that allow children to begin to form mental representations is important to us in view of the difficulties that children within the autistic spectrum experience with symbolic functioning. We believe that art, as a means of symbolic expression, gives a *particular form* to that which is being experienced, expressed and communicated. Like language, art has its own structures and mechanisms for creating, shaping and concretising 'meaning'. Both the making of art and art products themselves have particular communicative properties, which begin to emerge during the earliest stages of development.

Interest in children's art has emphasised the importance of the pre-schematic scribble stage of young children's drawings. Understanding has emerged of the complex planning strategies (Freeman 1985) required of children when drawing and the significance given by them to scribbles before pictorial representation. It is evident that in their very early mark-making activity, children are drawing with 'intent'.

The earliest stages of drawing development form an important period of playful experimentation that assists the development of a mechanism for understanding the complexities of representation of experience necessary for the development of the symbol systems for expression of more complex, abstract internal experience. This can be likened to Stern's (1985) 'emerging sense of self' and the later phases of Piaget's sensory motor stage described as pre-semiotic (Piaget and Inhelder 1969). All of these authors acknowledge that stages of development related to the organisation of sensory perceived experience forms the necessary foundations for the development of

symbolic functioning. Stern (1985) in particular emphasises the importance of 'intersubjectivity' as a fundamental part of pre-symbolic functioning development.

Our model of interactive art therapy is very much based on an understanding of pre-verbal intersubjective relatedness and how this contributes to the child's subsequent 'shaping' of his or her experience. It is the qualities inherent in this 'shaping' that provide the 'form' for communication, the meaningful and intentional sharing of experience with someone else. It may be that a stable shaping of experience and expression into form cannot be achieved consistently by some individuals with autism. This is often evident in both their behaviour and in their art work and we will be exploring this in more detail in Chapter 6.

Matthews describes this early phase of drawing development as follows:

> drawing as it emerges is assimilated into the arena of play with the consequence that drawing procedures themselves become pivotal phenomena around which symbolism of very different modes develop and alternate. Each two-dimensional representational system has its own uses and its own limitations. The child's task is to distinguish between representational systems so as to know how to develop them and when to apply them. Early representational systems are not merely abandoned in favour of new ones; rather something of the early systems is retained and forms the basis of later configuration. (Matthews 1984, p.38)

This kind of experience is free from the demands of having to make representations and encourages the development of a 'means' by which representations and symbols are made. In other words, it is through a phenomenological process that the child develops the 'representational insight' that leads to a sensitivity to symbolise.

Within interactive art therapy we largely focus on the vitality affects provided by different forms of art materials. Enhancing the vitality affect of the art therapy intervention may also be made by enhancing the vitality of the environment that the therapy takes place in. This may involve consideration of a number of features, for example the art materials made available by the therapist. Even the furnishings and lighting of the room will have different qualities which may affect the feeling state of the client. Widening the experience of art materials and mark-making techniques also widens the range of vitality affects that children experience and therefore their ability to develop a sensitivity towards these and towards their feelings. This contributes to their ability to make sense of (becoming more aware of) their experience by building some consistent reactions towards different things that they may encounter within the therapeutic environment. It is in this way, by moving the children into new areas of experience, that they are offered the opportunity to develop by cumulative experience, a sensitivity towards making representations and symbols.

For example, many children with autism display behaviours which are to a more or less extent rigid mechanical movements of the body, sometimes referred to as stereotyped behaviours. In developing interventions that reflect this end of the spectrum of behaviour, the therapist must take into account that such stereotypes may have arousal-reducing function for individuals who are physiologically over-aroused. If performance of a stereotypy temporarily reduces levels of arousal, we might hypothesise there will be a gradual return to the chronic arousal level which will in turn necessitate a repetition of the stereotype behaviour. Stereotypy can now be seen as a form of self-regulating behaviour, providing a form of homeostatic regulation. Methods of intervention in these cases therefore requires careful consideration on the part of the therapist as over-stimulation may cause great distress to the already over-aroused child.

We have also seen that there is a direct parallel between stereotype behaviour and the use of schematic drawing. The same schema produced by different media will result in a different vitality affect, the move from crayons to paint for example. To give an example from our work, one child displayed a common stereotyped behaviour of flicking his fingers and wrists constantly in front of his eyes. When introduced to a variety of art materials, his greatest preference was for wax crayons that he used to make the same flick-type marks on the paper. This behaviour further developed into him rigidly ordering these small finger and wrist movement produced marks on the sheet of paper working from left to right. When crayons were replaced with paint, he found it difficult to continue with such a rigidly stereotyped behaviour because of the need frequently to recharge his brush with paint.

While it may be very difficult and in some cases impossible to form interventions that will break the rigidity of the child's stereotypical or schematic behaviour, this change of media may nevertheless alter the vitality affect experienced by children in performing their rigid behaviour.

Trained art therapists are also artists, so we pay primary attention to the feeling and sensation that children experience in their use of materials, e.g. wetness, sharpness, textures. These are aspects we would share with them. We begin with the assumption that the use of the materials is non-representational or pre-representational. In this way we begin to develop a new vocabulary with the child, building a relationship indicating to the child that we have some sense between us, that we are sharing an understanding of the child's sense of awareness whatever that may be. The first stages of building a relationship are the beginnings of trust and empathy and also helping them to extend this new vocabulary through introducing new materials. Working at the affective, pre-representational level helps

children with an emerging 'sense of self', in the terms that Stern (1985) has used to describe the phases of early infant development.

Diagnosis, Understanding and Assessment

The descriptions and case examples that we have explored so far provide some indications concerning the condition of autism itself. In this chapter we look at how initial diagnosis is made and how people who are autistic themselves understand their condition.

Diagnosis of autism

The triad of impairments is the basis of the current criteria for diagnostic purposes, for example in the *Diagnostic and Statistical Manual of Mental Disorders* (DSM-IV: American Psychiatric Association 1994) and the International Classification of Diseases (ICD: World Health Organisation 1977, 1980, 1986). DSM-IV sets out the criteria and these are listed in three categories as:

- qualitative impairment in social interaction
- qualitative impairment in communication
- restricted repetitive and stereotyped patterns of behaviour.

Each category has several defining features and a total of six or more items from the three categories constitutes a diagnosis of autism.

It is generally agreed that diagnosis is difficult and current research seeks to establish assessment and criteria for diagnosis of autism earlier in childhood than has been possible up until now (Alcorn and

Bretherton 1997; Baron-Cohen, Allen and Gillberg 1992). This enables the introduction of an approach of treatment or management sooner rather than later, and therefore the potential for future long-term benefit is enhanced.

Autobiographical accounts of autism

Some individuals with autism have recovered, or have been more able to manage their condition, and have written about their experiences (Grandin and Scariano 1986; Miedzianik 1986; Williams 1996). These accounts give an enlightening view of autism that provides a further dimension alongside more theoretical perspectives.

Donna Williams, in her book *Autism: An Inside-Out Approach* (1996), debates the 'confusion' that literature such as that reviewed above has created by making definitions of the characteristics of autism. In this book she suggests that professionals in trying to explain autism have produced stereotypes of what 'autism' is, a 'tick-list' of criteria, that form the basis of diagnosis and suggests that now these exist the autistic person is judged on these. As an example she refers to conversations with fellow autistic individuals who revealed that they covered up the abilities they had in case they were interpreted as being 'exceptionally' talented or 'savant' (Williams 1996).

Sensory state

Williams (1996) emphasises the sensory side of the condition, a point previously reported by Gillingham (1995) in a study made on the autobiographies of several autistic individuals. According to these individuals, 'the problem of autism is linked to the senses...touch is excruciating...smells overpowering...sounds hurt...sight is distorted and tastes are too strong' (Gillingham 1995, p.12).

Temple Grandin, a recovered individual with autism (in her terms), also refers to being overwhelmed by the 'defect in the sensory system', describing how painful this is and the impossibility of thinking about emotions when all she was trying to do was to protect herself from the onslaught of terrible noise (Grandin and Scariano 1986).

The response by individuals with autism to these kinds of experiences has been described by Williams as 'systems forfeiting' or 'systems shutdown' – a means by which her brain is able to process more fully information on one channel at a time rather than spreading her processing more thinly. She continues that the eradication of symptoms, 'shutting down', may often be a relief to parents, professionals and carers and to some people with autism but that this approach is like seeking to 'cure' epilepsy by teaching people how to 'act normal' during the attack. This description gives insight into their experience and supports Meltzer's view (Meltzer *et al.* 1975, referred to in Alvarez 1992) that 'withdrawal' or 'shutting down' is not to be understood as a mechanism of defence against anxiety but exists as a response to a 'bombardment' of sensations that are felt as overwhelming.

Connecting the non-physical sensory to the physical sensory

More recently Williams (1998) directs us (as therapists) to think about connecting unconscious non-physical sensory experience to physical sensory conscious experience. We believe that this is an essential understanding of individuals with autism that informs our work. In Williams' own words:

> I was somewhere between three and five when my body called me. It wasn't like it phoned me up or anything, it was just that it started to make its presence felt as though nagging me to listen to it and respond to it. At first, I tuned out this foreign invasion as was natural and instinctive to do with

things that gave the feel of robbing one of control. Later, I tried to escape the sensed entrapment of physical connectedness, first spiritually by getting out of it and later physically by trying to pull it off from its suffocation of the me inside, slapping at it, punching it and later trying – physically – to run from it but the damn thing just came after me. As far as I was concerned, my body was welcome as a sensory tool but as a body with something of a competing will of its own, it was like a leech that happened to be there by coincidence but wouldn't take the hint and couldn't be got rid of. It was my first known enemy. (Williams 1998, p.53)

Charlotte

Reading this put us in mind of work currently engaged in with an 8-year-old girl with autism whom we have previously described as Charlotte. In the art therapy session she becomes absorbed with the paint and water, her nose is on the lip of the cup but barely touching it while she twirls the water vigorously, making slapping noises. During the session this activity is broken by taking the brush to the paper and making flicking marks (Figure 6.1).

These paintings are very representative of the *activity–pause rhythm* of every session we have had so far. During this period and using our knowledge from Williams' book, we have been gently encouraging Charlotte to 'attach' her 'will' (Williams' term) to her self and to the therapist. We are attempting to make her aware of where she is and what she is in contact with within the physical, interactive and emotional boundaries of the art therapy session which we hope is felt as containing and secure.

We came to this individual approach to Charlotte from early sessions, which were mainly observing what she was prepared to do in the session without any intervention on the part of the therapist other than having her whole attention focused on Charlotte

Figure 6.1 Charlotte's painting 5

modulated through the art materials. Later by gently calling her to the surroundings and painting alongside her within the sessions she has been coming out of her absorption with more frequency in the sessions.

Charlotte's paintings have remained the same throughout the therapy (see Chapter 5). Any development of them by her has been very subtle and at a later stage we believe demonstrate her feelings about herself in space and in relation to the therapist. They show very clearly when the therapist's attention was totally absorbed in her and when the therapist's body rhythms of activity and pause, also reflected in her mental rhythms, wavered slightly thereby removing her attention from Charlotte very subtly (see the illustrations in Chapter 5).

Painting 1 (Figure 5.1) opens the session; in painting 2 (Figure 5.2) the therapist's attention is distracted; in painting 3 (Figure 5.3)

the therapist's attention is totally encompassing and in painting 4 (Figure 5.4) it becomes slightly distracted again. However, at this point Charlotte has picked up the therapist's rhythms and allowed for this in the interaction and reflected it in her painting. Just as the therapist has a sensitivity towards the feelings and emotions of the child she is working with, so the child in turn has reciprocal feelings and acts on these. As Charlotte demonstrates, these may be at a very primary, unconscious, level of experience but she is showing the therapist that she is involved in the interaction with her.

Interactive art therapy model

Our work with Charlotte serves to illustrate many aspects of the interactive art therapy model, an approach that is based on an understanding of the quality of experience that begins in early infancy and develops throughout childhood, of infant–caregiver relations.

We consider the early stages of drawing development to be an intrinsic part of this understanding and this also forms part of the platform of our assessment process.

Assessment process

The assessment process is largely concerned with the identification of these two aspects, the quality and form of intersubjective relations between child and therapist on the one hand and the child's use of the art-making process on the other. Following assessment, these two aspects continue to form the basis of future therapeutic interventions.

Whenever possible we try to follow a two-stage assessment process; the first stage consists of observing the child within her or his 'natural' surroundings which may be, for example, at school or at home. This first stage serves a number of functions, not least providing the child with the opportunity of getting used to the therapist; we have already described in detail this process with David

in Chapter 4. Observations and notes made by the therapist during this stage will be invaluable in setting up the first assessment art therapy session. Whenever possible, we video-record this first session for future micro-analysis.

In the second stage, soon after the referral and usually before beginning to make observations, the therapist will study any case history notes about the child that can be made available, together with school records and, if appropriate, previous art therapy records. (Individual approach of the art therapist determines whether this step is necessary, as some art therapists find that this hinders their assessment.) During this process we think it important to check Educational Statements for any children referred for art therapy.

The primary aim of the assessment is to collect as much information about the child as possible and it should include notes from previous case history reports and other psychological or assessment tests carried out on the child. We would comment, however, that from discussion with art therapists, some might consider that acquiring too much information about the child before contact with them may colour the perspective taken of the children. In these circumstances some art therapists might prefer to meet the child without any prior knowledge and build for themselves what might be a clearer and more individual profile unhampered by preconceived or stereotype ideas.

Art therapy assessment session

An art therapy assessment session is typically set up using the same structures as for a therapy session. The room should have a wide range of art materials and utensils available such as clay or Play-Doh with rolling pins and cutters, paints, a good selection of different sizes of paper, paints and brushes of differing sizes, crayons, sand and toys. The duration of the assessment session should reflect the pattern of anticipated future sessions, but as this will be based in part on factors

such as the child's concentration and attention span, it may not be possible to fix this until after the assessment session. Typically, sessions of art therapy run for 50–60 minutes but might be of a considerably shorter period for some children, especially during the earliest phases of therapy.

Video-recording

We have found it invaluable to have a video-recording of the first assessment session for further detailed observation by the art therapist. We have stressed the importance of micro-analysis of the first session as this provides a number of robust indicators regarding the child's behaviour towards both the therapist and the therapy itself. The analysis of this behaviour by the therapist is considered an essential element of the model that we propose. It is via this micro-analysis that the therapist begins to enter the world of the client, within which the therapist needs to find a place if a therapeutic relationship is to develop. We shall now provide some indicators of what we might expect to find within the micro-analysis and how these factors form an integral part of the assessment process itself. Essentially this consists of the identification of interactions between therapist, child and drawing activities.

Interactions between therapist, child and drawing activities

Primary consideration is made of the assessment of interactive behaviour, engagement with the art-making process and engagement with the art therapist. Areas such as *spontaneity* are explored by asking questions such as whether the child engages with the art-making process in any way. Does the child initiate exploration of materials and experiment with them? Does the child show curiosity? The area of *attention* is explored through asking questions such as whether the child requires and/or initiates joint attention (both child and

therapist attending together) to the activity. Does the child seek the attention of the art therapist and what is the nature of the attention that is sought? For example is it a joint reciprocal dialogue or one-sided or echolaic exchange? We have already stressed the importance of *attunement,* and observations of interactions such as whether the art therapist and child move in rhythm together and whether they are comfortable with each other are important indicators of this. The area of *interaction* itself is explored: does the behaviour have the potential to initiate, sustain or spiral an interaction? Is it directed toward the other person as a person rather than being merely incidental to the presence of that person (Nind and Hewett 1994)? Another area for consideration is *turn taking:* can the child develop a turn-taking interaction with the art therapist, e.g. 'You draw something, I draw something' (Rutten-Saris 1990)? Questions concerning the quality of *exchange* include whether the child accepts something new when he or she is introduced to the interaction. Does the child notice and include it into his or her actions? Another area concerns what we call *return–exchange:* in turn can the child introduce something new into the exchange and notice when the art therapist picks this up? Another area we refer to as *play–dialogue* is explored through asking if the child enters into 'let's pretend' playful interactions or 'as if' situations; one indication of this might be whether the child imitates or gives names to non-representational scribbles. The next area for consideration is the nature and quality of *verbal–non-verbal* communication: does the child use language? Is the language used unusual; if so in what way? Does the child describe what he or she is drawing while drawing? The nature of any *testing* behaviour is considered: is the child looking for a reaction from the therapist's behaviour, for example the child throws pencils to the floor purposefully and then pauses and looks at the therapist expectantly? We also look for indications regarding the child's awareness of their sensitivity towards objects, people or anything in the envi-

ronment. Examples of these *vitality effects* might include their reaction to the hardness or softness of surfaces; their sensitivity to colour; sensitivity to stimuli, quality and textures of things, e.g. slippery, sticky, dry, brittle or pointy.

Microanalysis of video-recordings

We have consistently stressed the importance of the first therapy session and how we use this as the basis for initial assessment. We have further stressed that the micro-analysis of video-recordings of the first session has become a vital tool in our work.

This normally begins with a minute-by-minute analysis of the recorded footage, viewing this in slow motion or even frame by frame.

This involves the marking of behaviour sequences building up to pauses that may indicate a progression or shift in client–therapist interaction, for example sequences of behaviour building up to a communicative interaction such as eye play units:

Opening: the eyes are open, in the middle

Orientation: the eyes move to the corner

Blink: blinking, fast up and down

Finishing: blinking, slows down

Ending: closed eyes

(Montagner, Restoin and Henry 1982, pp.210–211)

Other examples may involve the child's attention from interacting with materials to looking out of a window or from looking towards the therapist to looking away.

Areas we have found useful to look for in the micro-analysis include *pauses*: as well as often indicating shifts from one behavioural sequence to another, pauses can be an indicator of communicative

sensitivity in themselves. In analysing pauses the nature of the pause should be noted; for example is the child showing signs of distress indicating that he or she is wanting to leave the situation? In noting how pauses might indicate communicative sensitivities or an increase in anxiety, for example, it may then be necessary to select and analyse one minute of the first session where communicative sensitivity is evident. It is useful in identifying the behavioural sequences which lead to an escalation of distress in the child. It may be that this is evident in the first minutes of the first session as in the case of Stephen (see Chapter 1), or later in the first session as we saw with David (see Chapter 4).

Micro-analysis of interactions between therapist and child identified points of extreme sensitivity, affecting and restricting the development of the relationship. It showed how interactive behaviours and the reciprocal cues from each party in the dialogue take place so fleetingly they cannot be acted upon in the normal course of the therapy without a heightened awareness on the part of the therapist. This requires 'frame by frame analysis...which may reveal things that otherwise remain outside our awareness because they happen too quickly or are embedded in too complex an array of events' (Condon and Sander 1974, indirectly quoted by Grayson and Grant 1995, p.161). The assessment procedure is also very useful in raising the awareness of the therapist to the subtleties of communicative interactions with these children at the earliest possible stage in the art therapy.

Information from assessment

The assessment procedure indicates where the focus of the interventions in the therapy should initially be, and by ongoing assessment in the same manner, how these can be developed. In analysing the assessments that we have conducted, we have found it useful to consider the children on the basis on their communication sensitivities.

The information gained from assessment and video analysis will indicate a number of areas which can provide a template from which to develop the assessment and monitoring of the art therapy:

- The behaviour patterns that the child engages in which appear consistently throughout the art therapy sessions; these need to be worked with, and will form a basis for assessment and monitoring of the therapy.

- The set behaviour patterns learned in response to interactions with another person; interventions that can be made to break into the set pattern and develop the interaction.

- The level of pathology of these set behaviour patterns; the point at which the child withdraws or cuts off the interaction; examples of motivational conflict, stereotype behaviour or use of schematic drawings.

The assessment session and subsequent micro-analysis provide the therapist with the vital cues necessary to initiate the beginnings of a therapeutic relationship with the autistic child. Art as an alternative means of communication forms an integral part of this process. The sharing of subjective phenomena emanating from both unconscious and conscious material are the result of achieving a successful therapeutic relationship. Within art therapy we have the additional concrete representation of this in the form of the physical art work which can produce powerful reactions in the child.

Equally, the therapist's response to the kind of perceptual experience of communication involved in art making and the resulting art work occurs holistically – an experience that encompasses the art work and person in commune. This cannot be broken down, in our opinion, into elements for explanation in spoken language without losing the essential understanding of a non-verbal experience. This awareness of responses enables therapists to contain their clients' ex-

perience and help them to recognise and realise feelings and emotions that are evoked and to express these concretely in the form of art making and art work.

Practical interventions in the art therapy can now be informed from what has been learned from both the therapist's direct experience of the child during the assessment session and the subsequent micro-analysis of that session. To summarise, the development of the therapeutic relationship is via establishing attunement and a working alliance and this has to be achieved before the therapeutic relationship can begin to develop. Both the quality of attunement and the subsequent therapeutic alliance are achieved in the development of the art-making process itself. The quality of the experience provided by the pre-representational drawing activities enables the construction of a scaffolding for the later development of more complex symbol systems.

Attunement

Attunement between therapist and client forms the basis of many of our interactions. Elements of behaviour that frequently occur include *rhythm*, which may take the form of reciprocal dipping, bobbing and moving together, reflected back by the therapist via body/hand/ head movements indicated in the child's movements. Because of the subtlety of such rhythms these may not be fully picked up by the therapist prior to micro-analysis. Once the therapist feels comfortable with the child, attuned movements can be reflected back, slightly exaggerating these to make the child aware of his or her own movements and actions. This is not mirroring, but tuning into the children's experience as naturally and comfortably as possible. The quality of attunement may be determined by the child's *approach– retreat sensitivity*: how tolerant is the child of the art therapist's presence? Building up tolerance can sometimes be achieved by a method of approaching and retreating, gradually moving closer.

Another aspect that we have identified is *horizontal–vertical positioning*, an indicator of power and control of the relationship between client and therapist: by adjusting position the art therapist can empower the child in his or her ability to communicate what (and how) the child is able to tolerate in terms of interaction. It may be useful for the therapist to assume an *invitation position*, in which the head is tilted to the side, body position level or below the child, without the use of eye contact or language: this can invite the child into an interaction.

The use of *eye contact* may not be tolerable for the child and accordingly the therapist should follow the child's lead as to how much eye contact the child can tolerate while at the same time being aware as to what he or she is communicating through this. It is frequently the case that focusing direct attention to the child causes some distress, but it is important that the art therapist is totally absorbed in what the child is doing and what they are doing together. This may involve being wholly engrossed and focused on the art work being made by the child; we call this form of focus *environmental activation*.

Being in attunement with the child can increase the therapist's sensitivity regarding the use of *pauses* or *break*: signs for a need to pause or break in the activity usually occur when stimulus is overwhelming for the child, prompting the therapist to draw back or move aside. It is through these forms of negotiation between the therapist and the child that a more relaxed atmosphere can develop, leading to the possibilities for interactions such as *turn taking* – 'You draw something, I draw something' – which can lead to *exchange*. Here the art therapist introduces a new element of behaviour into the interaction, or the art therapist picks up a new element introduced by the child, which is assimilated into the turn taking and acknowledged. Monitoring of the child's tolerance level is achieved as the art therapist establishes a level of sensitivity towards his or her interactive behaviours with the child and introduces a new element to challenge emotional and communicative sensitivity to 'move' the child, thereby

extending the child's tolerance level. Such sensitivity may be identi-
fied as a form of *hesitation*: the art therapist refrains from filling gaps in
interaction thereby giving the child a chance to make a move of his or
her own volition. This may be a very subtly perceived 'pause' made
by the child (as if taking time to process something). Empowering the
child in this way can lead to a more playful exchange in which the art
therapist introduces a new element into the interaction and the child
responds by imitating this and then introducing a new element of his
or her own. This shows an understanding of the significance of the
interaction and the possibilities for creating *imaginative* play.

Stereotyped behaviour

One of the greatest obstacles to achieving the possibility for imagina-
tive play is the prevalence of *schematic drawing and activity*. The poles of
movement around this activity are from schematic (formula type)
drawing (for example David's art work in Chapter 4) using one set of
drawing devices and materials, to a child whose approach to the
material is totally chaotic, flitting from one activity to another. At one
end of the spectrum we see variations of stereotyped behaviour
reflected in drawing activity such as rocking and looking away from
the picture surface while the rocking movements leave a trace. Com-
plicated hand manipulations may also occur, resulting in more
complex marks being produced, again frequently not directly
attended to by the child. Another frequent variation of stereotyped
behaviour is finger flicking, which may be translated into paint
flicking.

All of these behaviours imply, to a greater or lesser extent, rigid
mechanical movements of the body but in many cases such behav-
iours become embellished into complex movements requiring both
great attention to the activity and frequently some dexterity and skill.
In developing interventions that reflect this end of the spectrum of
behaviour, the therapist must take into account that such stereotypes

may have an arousal-reducing function in individuals who are physiologically over-aroused. If performance of a stereotypy temporarily reduces levels of arousal, we might hypothesise that there will be a gradual return to the chronic arousal level, when the stereotypy is again performed. If we consider stereotypy to be a form of self-regulating behaviour, providing a form of homeostatic regulation for over-stimulation then we can understand that these behaviours occur when the level of stimulation available to the client is either too low or too high. Methods of intervention in these cases requires careful consideration as over-stimulation may cause great distress to the already over-aroused child.

As we have seen, stereotyped behaviour is frequently reflected in the drawings made by autistic children; these anomalous drawings are usually schematic and can be readily identified. They are produced by using a set of drawing devices, or a behavioural approach to the mark-making, which are used inflexibly, rigidly or repetitively; they are circular in nature and they do not develop the representational possibilities of the activity.

Interpretation of the assessment procedure

Our assessment procedure provides a perspective of each child that leads to a unique profile from which to plan interventions in the therapy on an ongoing basis. It shows where the focus of the work should initially be and how the children are able to communicate with the therapist in their own way. From our work so far the children we have assessed have fallen loosely into three groups: non-directive, directive and acute sensitive.

Non-directive

For some children, concentrating on the interaction and using body language creatively *is* the art therapy and consists largely on

following rhythms of their movement, the pauses, activity and eye contact. The therapist is not mirroring these but 'tuning' into the children's experience as naturally and comfortably as possible. The whole room and whatever is in it may be drawn into the interaction and become art materials. These children require a non-directive approach.

Directive

Other children are seemingly more contained. They could be described as compliant, as if trained in certain situations where they have come to know what is expected of them. With these children it is possible to work with art materials in the more traditional way. This is a directive approach. The aim is to encourage them to use a wide variety of art materials in as many ways as possible. (This approach is demonstrated by the art therapy with David.)

Acute sensitive

For some children with autism, whatever they are experiencing, for example any social situation, may be too sensitive and overwhelming for them (as in the case of Stephen). With children like these, any contact or approach may be too unbearable and strategies need to be created to overcome them such as the retreat/approach ritual described. In circumstances such as these therapists' experience may be of feeling that they have been thrown out of the session. The child resorts to 'systems shut down', as Donna Williams (1996) describes this situation, in a desperate need to control the experience. Using the interactive model and assessment procedure, we are increasingly alerted to the requirement of therapists to have a heightened awareness of the subtleties of their interactions with children with autism. Chapter 7 is based on the analysis of the assessment and con-

sequent sessions with one of the children we have worked with, Stephen.

Working with Stephen

This analysis of Stephen's material has led to the identification of a number of factors which have informed us in the development of our instrument for assessing and monitoring the process of art therapy with autistic children. In particular, this case highlights the difficulties in working with children who are autistic and whose communicative sensitivity is so overwhelming as to prevent a working alliance being formed at all.

So far we have discussed how our model on interactive art therapy has led to an assessment methodology based on therapeutic interactions that are essentially 'intersubjective'. In order to illustrate in greater detail how the model actually operates, this chapter provides a more in-depth description of our procedures.

Our approaches to autism are based predominantly on understandings of cause and descriptions of symptomology. These are covered by a wide range of literature from published research findings to autobiographical accounts of adult individuals with autism who have recovered sufficiently to write about their experiences. The purpose of this chapter is not to review these but to ground theoretical viewpoints of art therapy and autism firmly in the actual day-to-day experience of the art therapist's working life with this client group. We hope therefore to give the reader the opportunity to become absorbed in a first-hand account of art therapy with a child

with autism in order to come to an understanding of some of the complex difficulties that autism presents in the child.

Stephen was between the age of 7 and 9 years old when he attended art therapy sessions. He was given a diagnosis of autism when he was 3 years old. His behaviour was very typically within the autistic spectrum if we compare it to the diagnostic criteria for autism under 299.00 Autistic Disorder of the *Diagnostic and Statistical Manual of Mental Disorders* (DSM-IV: American Psychiatric Association 1994).

The setting for the art therapy was within a special school for autism. The school is fairly small (approximately eighty children), with a residential part set aside from the main buildings. Our therapy sessions took place in the residential part of the school during the early evening for thirty minutes a session, once a week, during term time over a two-year period. Stephen had twenty-seven sessions of art therapy in total. The school ran a programme of early evening activities that started immediately after school for the children who board. Prior to beginning therapy, Stephen was observed by the art therapist during these activities on a number of occasions and we begin with her first impressions.

First impressions and contact with Stephen

Lorna Wing (1996) comments that most autistic children look physically normal and are often very attractive: 'not least because of the quality of mysterious remoteness' (p.27). Frances Tustin describes 'encapsulation children':

> almost invariably these children have well-formed limbs and beautiful, 'other worldly' faces. They often have such a translucent skin that they look like 'fairy children'…their body movements are nimble and graceful, although they may walk on their toes. (Tustin 1981, p.46)

The first contact with Stephen took place in the evening activities. Stephen was a member of a younger group in the residential facility. There were nineteen children who boarded weekly and these were divided into three groups for activities – the elder group were aged 11–14, the two younger groups covered the age range 5–11.

At this time I became aware of him in the room; in appearance he had a slight frame, delicate features and translucent skin.

Stephen very much fitted the descriptions by Wing and Tustin and his general coordination as he moved around his environment was good. In the initial encounters he appeared to be withdrawn and highly sensitive about his personal space, reacting quite violently sometimes if people approached him too closely.

On three separate occasions in the evening activities, there was some interaction between Stephen and myself which, in retrospect, proved to be significant in indicating some of the consistent features of the art therapy that followed. In our first interaction an elaborate *approach–retreat sequence* built up between us, resulting in Stephen engaging in drawing activity.

This sequence began with Stephen peeking out from behind the curtain across the room from where I was sitting. We engaged fleetingly in eye contact from which he withdrew behind the curtain. This happened frequently over a period of several minutes after which he came and sat under the table hidden from my view. Our interaction continued and consisted of me placing a crayon in his hand which would appear on the table top, him taking the crayon down underneath the table to draw with and then putting his hand up with the crayon to exchange it for another one. The drawings he made appeared very much at the earliest stages of drawing development, the kind that young infants make at the age of 18 months to 2 years (see Figure 7.1).

Figure 7.1 Stephen's first scribbles

Stephen's sensitivity towards other people and myself in terms of his personal space remained with us throughout the two years I had contact with him. Moving too closely or too quickly into his space made him react at times quite violently. However, by observing his reactions closely and behaving sensitively with him showed that he appeared to enjoy close interactions and at times desired closeness with other people.

There were two periods during the art therapy (sessions 7–9 and 13–16) when the elaborate *approach–retreat sequence* experienced in the pre-therapy activities emerged again and became a ritual when fetching Stephen for art therapy. When I entered the room to collect him he would ignore my presence. Carefully avoiding eye contact with him, I would sit across the room from him, then gradually move closer; eventually he would come to me. Sometimes he would put his hand around my neck (provided I did not look at him) and then I would stand up and go to the door, my back towards him and he would follow me up to the art therapy room. This routine could take up to ten minutes.

Although sensitive to his personal bodily space, he was also a very sensual little boy; he appeared very attracted to textures, running his hands delicately over different surfaces and materials and being touched on his terms. For example, in the ritual above he would approach me and throw his arm around my neck and this felt very much as if he wanted a cuddle. However, I had to observe his rules, not instigate engaging in eye contact or making any moves towards him.

At times he would fleetingly touch or handle some objects, such as sharp pencils, then throw them away from him violently as if he felt something from them, possibly that they were *pointy* or *stabbing*, that made him react in this way; a sharp vocalisation would often accompany these actions. In comparison other objects that were created during the art-making process between us, such as squeezed tissue from mopping up spilt water, would be *caressed*, flicked or twiddled in his fingers and then allowed to drop by themselves from his hand. Stephen was showing his perception of the different *vitality effects* that different objects and situations radiate.

Our initial encounters in art therapy proved both sensitive and chaotic, each session was different. At times Stephen could be very aggressive and at others extremely affectionate and passive. He would *take turns* and enter an activity that was initiated by the therapist, for example if I held his hand with the brush and painted with him.

Consistent with my routines in the therapy, such as always returning to drawing or painting myself when I felt at a loss to know what to do, my actions became predictable to Stephen. This predictability seemed to alleviate Stephen's anxiety and behaviour associated with it to the point that it enabled new and novel activities between us to develop. For example between sessions 16 and 19, I was able to introduce water play and in these ways he became able to accept my presence, and at times enter into certain interactions with me which he might have experienced as distressing at other times.

Sometimes a mismatch in our interactions resulted in mounting tension. When this occurred, he would typically take an object such as a toy animal or pencil and drum it on the table or window ledge. The tapping would be accompanied by a dance in which his whole body would move in a coordinated rhythm. At times he would often giggle to himself, as if at a private joke. He would then attempt to throw the toy out of the window, or poke the pencils behind the radiator. These rituals involved Stephen in being both secretive in the way that he would check if I was watching him and at the same time looking for my reaction. Throughout these sessions Stephen consistently displayed stereotype behaviour, a rhythmic dance involving the whole of his body and which included tapping an 'object' on a hard surface at the same time. He did not display any spontaneous behaviour and most of the time appeared *cut off* from his surroundings.

Our water play provides a very good example of an activity that may become an *autistic object activity* in the way that Tustin (1981) describes *autistic objects*. In the sessions he would fill beakers of water and tip them over his head and then take my hand to pat his head. He would be wrapped in a towel to contain the water from drenching his clothes. Sequences of this behaviour occurred in several sessions and I sensed that he found them pleasurable. The interaction between us also felt comfortable as he seemed to want to interact with me, including encouraging me to pat his head. This felt very different from his consistently wanting to 'put' space between us. However, he took this activity (tipping water over his head) out of the session into break times in school and began to tip his orange juice over his head. This seemed to indicate that the significance of the activity was held in the objects (and activity), not in attachment or association to a person in the context of being in therapy. As such, in a different setting this activity was triggered by the similarity in the objects involved (cup, liquid, pleasurable sensation of the water running over

him) rather than the water play having had significant attachment to the interactive relationship between us in the session from where it derived.

Following this experience with Stephen, careful consideration was given to the materials used and activities being experienced in the session with regard to their variability. Containers of all sorts and contents were introduced into the sessions (sessions 17–24) along with a variety of art materials to widen the range of activities in order to avoid focusing on one which might potentially develop into 'autistic' occupations.

Stephen's art work

Stephen's drawings were very similar to the mark-making that infants engage in when first they come in contact with drawing materials, usually around the age of 12–18 months. In the activity sessions prior to art therapy Stephen seemed to enter the art-making process spontaneously, following an interactive sequence of familiarisation between us. However, this proved to be the only spontaneous engagement with art materials as he did not engage in this way again within our formal therapy sessions.

Stephen's parents informed us that he was encouraged to draw from when he was about 2 years old. They provided an early example (Figure 7.2). These early paintings were described as 'random splodgings with paint, scrubbing and sweeping movements' and he 'was interested' to use all of the colours available. His parents reported that drawing and painting was something that Stephen enjoyed doing but that it depended very much on *his terms* and *frame of mind*. Stephen did make some scribbles but these were made in a lethargic way and came from encouragement on my part in attempting to engage him in turn-taking activities. From session 5 onwards he became increasingly interested in water, tipping it over the table and then his head, and I mopped the water up: from this an activity

Figure 7.2 Stephen's painting 1

developed. Stephen began to mop the water up himself and squeezed the tissue; the resulting object was 'flicked' or 'twiddled' in his hand and then allowed to drop (of its own accord) to the floor. I picked these up and placed them on a sheet of paper (Figure 7.3). This activity developed further, with the introduction of 'pulp' paper, which is very absorbent, so that when the water was spilt it would be sucked up rapidly. This was in order to magnify the *vitality affect* experience of the materials, sensuous qualities such as slipperiness, smoothness, whiteness, sharpness and the *temporal affect* such as water running out of control rapidly over smooth paper or being taken in more slowly into absorbent paper. It may also have the effect of Stephen *being absorbed*, becoming attentively involved with these processes. In later sessions this initial water play developed into the *autistic object activity* described previously when Stephen began to tip the water over his head.

Figure 7.3 Stephen's twiddled tissues

Towards the end of our work together between sessions 24 and 27, I introduced large sheets of paper (the same size as Stephen) attached to the wall and he was encouraged to paint on these (Figure 7.4). I was interested to see whether his whole body stereotyped movements might be translated into large brush movements on this very large sheet of paper. His response was consistent with his approach throughout our sessions together in that he was lethargic, seemingly unaware or *cut off* from his surroundings. He required a great deal of encouragement, for example I would load the brush with paint, put it in his hand and take him to the paper.

Although I consistently attempted to engage Stephen in this large painting activity, most of these large *messy* paintings were made by myself, with Stephen standing apart and side on from me, usually at the window or wall, seemingly *cut off* from his surroundings.

However, in reviewing this behaviour on the video-recording, he can be seen to *glance* regularly at my activity with the art materials. Considering this afterwards I wondered whether I was painting *for him*, and that Stephen was able to engage in the art-making process through my *agency of substitution*.

Figure 7.4 Stephen's painting 2

Thoughts following the completion of art therapy with Stephen

Most of the art therapy sessions with Stephen were video-recorded in order to enable me to observe the interactive behaviours in more detail. One of the advantages of doing this is that it allows for an increasing awareness of the minute interactions, reciprocal cues and interventions that take place. These are often so fleeting that they

cannot be acted upon in the normal course of the therapy without a heightened awareness on my part gained from studying the video-recordings.

Stephen was very aware of the video-recorder and moved out of view of the camera much of the time. Despite this and from the limited material available, it was possible to identify patterns and sequences of behaviour that proved useful in heightening my awareness as to what was happening in the interaction with Stephen and informed in this way, there was the potential of improving the communication between us. Stephen's response to interaction with another person can be clearly seen in the first few minutes of our first session. We can see that I attempt to engage him in an interaction. This involves moving towards him and offering him materials; a sequence of interactions follows involving my moving in and Stephen moving away. Mutual interaction including eye contact is achieved momentarily followed by Stephen curling up, covering his head and eyes and lying forward on the table as if this fleeting contact was too much for him to cope with.

Throughout this chapter it has been commented on that Stephen reacted anxiously to other people's proximity. This view was reinforced when reviewing the video-recordings of the sessions. When my attention is removed from him and I focus on my own painting (the attention of the session is removed from direct interaction between us) it can be seen to have a quietening effect on him. At other times, extreme distress is experienced by Stephen when I move into his space to close the window; his response to this is to turn and attack me violently.

Studying short extracts of between one and three minutes of the video-recordings micro-analytically (frame by frame) revealed rhythms emerging from pauses, attention spans and particular body and hand movements, and for sequences of these to be identified in the interaction between me and Stephen. In the first minutes of the

first session we can be observed moving in and out of our interaction, looking down, then up, before pausing, Stephen flapping his hands, looking down and again pausing. These interactions are fluid and lead to sustained pauses with full eye contact and then withdrawal on Stephen's part by covering his eyes and head and lying on the table. These sequences of mutual rhythmic interaction can be seen throughout the course of the art therapy sessions and at times resulted in Stephen's stereotype rhythmic body dance and tapping.

If approached too closely, Stephen would 'shriek' or jump back or raise his arm as if to 'smack' me. If I moved into his space too quickly, he would react violently, sometimes to the point of kicking and screaming. He would give a warning that the interaction was overwhelming him and this was clearly evident from the video-recording. Stephen would sustain *looking down*, then *screw his eyes up*, then peer *off into the distance*. Eventually he would cover his head and eyes if the interaction was pursued by me. It was not until the micro-analysis that I was able to see and understand the importance of my failure to *pause* in the rhythm of our interaction.

It seems clear that throughout the art therapy there appeared to be a mismatch in our interaction and this was mainly on my part, missing the cues and signals given out by Stephen as to how close I could be to him without causing him distress. These were so subtle that it was not possible to pick them up without recourse to the video analysis.

Due to this *unawareness* a comfortable starting point for a *working alliance* to develop was never achieved consistently enough for it to develop into the fuller therapeutic relationship. *Attunement* (in the form of a comfortable being together) was achieved at times but these episodes were fleeting and did not develop.

Introduction of new elements into the art therapy

Some comment should be made about the introduction of new elements into the art therapy to illustrate how interventions were created in response to Stephen's individual autism.

In the initial sessions (sessions 1–10) the art materials were limited: this was a directive approach aimed at reducing stimulation and offering the opportunity to gauge Stephen's reaction to the therapy situation. Water play developed out of this phase and became the major medium in our interaction; the materials were limited further to paper, water, towels and cushions. After session 18 water play ceased and a wide range of materials were introduced to vary the activity: containers with many different contents such as crayons, currants, modelling clay, shapes in jars, and even at one point making paper aeroplanes and flying them. In the last three sessions the materials and activity were limited: paper was fixed to the wall and paints were used. Stephen tolerated all of these situations and the introduction of new elements but did not initiate any contact with them; he appeared to *watch* the situation at the same time as *accepting* it.

Stephen's sensitivity to close interaction remained under the surface throughout the art therapy and this did not allow a consistent *attunement* to be achieved. However, I became predictable to him and he was therefore able to tolerate me, and allowed me to introduce new elements into the session. There was only one consistent and sustained interaction during the therapy which included the use of materials in a creative way, the use of water and tissues but this quickly developed into an *autistic object activity*.

Summary

My predictability in the course of the art therapy sessions resulted in an increase in Stephen's level of toleration of events based on interac-

tive sequences which involved my agency in substituting for him. The following points summarise these:

- Stephen paid attention to my actions, although he did not want me to know this; an example is when he was watching me while I was engaged in painting or some other activity.

- He can be observed on the video-recording looking at the brushes and materials with great interest while I was not in the room.

- He became able to predict what would occur between us in the sessions. This predictability allowed him to explore our relationship a little.

- Stephen was able to introduce a new element into the session, such as *spilling the water* and watching for my reaction.

Stephen has his own way of coping with his autism: he dealt with anxiety about interaction by 'cutting off' very severely in a variety of ways, such as avoiding or deviant eye contact, stereotype behaviour or the use of aggression. The patterns and sequences of behaviour that led to 'cutting off' could be analysed in detail from the video-recording of the first session. For example, although Stephen did not use language he was very well able to communicate through body language and exclamations what he did or did not like and at times what he wanted. This allowed him to manage his autism, his extreme sensitivity to social interaction, but did not allow for a response or interaction from another party. At the same time it meant that the flow of rhythmic interactions between us did not allow consistent *attunement* to take place and resulted in a continual mismatch in the reciprocity of our interactions.

His avoidance or *cut-off* behaviour related to art-making processes and art work resulted in activities that became circular in nature. Stephen demonstrated sets of drawing devices or behaviours within

the approach to the activity that were repetitive and became very *stuck*, that is the art materials were not used flexibly or imaginatively.

We consider that this inability for children with autism to interact with the therapist or art-making activities imaginatively is due to their anxieties about the communicative interactions between the therapist and themselves. This also relates to the difficulties they often experience with transitional phases of development, for example, when making associations between what they *know*, that is, strategies or concepts they have learned in order to cope with situations, and new experiences for which they do not have strategies and which in the course of normal development would be assimilated into the previously formed concepts.

Our work with children with autism indicates that rather than following stages of normal drawing developmental process they acquire sets of drawing devices, or an approach to the activity which becomes fixed, rigidified and circular in character. This anomalous development does not assimilate, differentiate or develop the representational possibilities of the activity.

Coupled with the often severe communication difficulties that these children demonstrate, the development of attunement or a working alliance is not possible as these require forms of interactive and intersubjective exchanges between the child and the therapist with them sharing an understanding about these.

In the introduction we established that communication is synonymous with relationship and both aspects are fundamental to art therapy. The therapeutic relationship is based on building a special kind of relationship between the therapist and the child with autism. Social interaction, communication, language and relationships are all sensitive experiences for children with autism and make developing a therapeutic relationship extremely difficult.

Following our description of the art therapy with Stephen, we can see that children with autism require considerable work in the therapy

to establish *attunement* and a *working alliance* before a therapeutic relationship in its fullest sense can be achieved. This involves understanding the subtle manifestation of each child's unique communicative sensitivity. It would be very difficult in the light of the work with Stephen to specify how long this would take to achieve in terms of art therapy sessions.

Stephen is one example of many children with autism; each one is unique and individual in the way that autism affects them. He demonstrates very well the complex perception of the world and the relationship these children have with objects and self and with people and self.

Developing an Interactive Art Therapy Template

In developing this model of interactive art therapy, we have found that an analysis of the first session of art therapy can provide a very effective 'template' that can then be applied to all subsequent sessions. The first session of art therapy (possibly the first minutes of the first session) with an autistic child provides a reliable guide to the ensuing therapy from which it is then possible to assess and monitor progress within the framework of the 'interactive' approach. The development of an individual interactive template for a child referred for art therapy typically takes the following factors into account.

Anxiety/social interaction/'cutting off'

The anxiety experienced by children with autism resulting in 'cutting off' was identified as occurring when social interaction between the art therapist and child required a more complex communicative means of expression and sharing understanding.

Analysis of behaviour sequences/'cutting off'/signalling a warning

Factors in the behaviour sequences which lead to 'cutting off' could be observed micro-analytically on the video-recording. These factors signal (subtly and imperceptibly) a warning that the autistic child was

seeking to secure a safe context to be in, and to be with the art therapist. If this was not secured then distress would result followed by avoidance behaviour or 'withdrawal'.

The art therapist as a 'potent' intervention

The art therapist in the session with the autistic child is 'there' in the sense that Stern (1985) refers to the 'activation contour' of human experience. The therapist is with the child in this interactive process and the child can attach to and use the therapist as a 'vehicle' for his or her experience. Together they identify the rhythms of experience; the art therapist's vitality affect in this situation (activation contour) is of being 'consistent'. Rhythm can form from and around the therapist's 'sameness' because it is 'stable' and predictable and is given 'shape' through the interactions between child and therapist.

In the interactive art therapy process, the therapist reciprocates the actions of the child, therefore these actions directly affect the development of the relationship. It may be that in the reciprocal cueing in the communicative dialogue, the therapist mismatches cues from the child because they may be deviant or anomalous. Art therapists therefore need to develop their skills in the interactive art therapy process with autistic children if they are to become 'potent' interventions themselves.

The art therapist heightening awareness

Some of the behaviour sequences we have identified have been described as 'subtle and imperceptible' and require close observation if they are to be picked up and used as an intervention to facilitate the interactive dialogue between the therapist and child. The indications are that art therapists are required to 'heighten' their awareness of these 'cues' and this would initially demand training by observation of art therapy sessions in micro-analytical detail.

Research into autism

A considerable amount of research has been carried out into autistic spectrum disorder since the mid-1990s. This has resulted in increased public awareness: new approaches to the management and treatment of the condition consistently come to attention. New treatments raise the hopes of parents and carers of individuals with autism, but many of these suggested 'cures' have not been evaluated rigorously nor have longitudinal studies been conducted to provide evidence of eventual effectiveness. The National Autistic Society has called for evaluation of all approaches to treatment of autism and carried out research itself (Collins, Gould and Mills 1995; Jordan, Jones and Murray 1998).

The role of art therapy

Art therapy can be seen to be an emerging new discipline whose practice has diversified across an increasingly wide range of client groups since the mid-1980s. This has given rise to a requirement for evaluation of work with specific groups of client such as children with autism.

Most of the early work of the project that has culminated with this book indicated that for art therapy to be effective in working with children who have autism, it needed to reformulate its model of practice. This led to evaluating the skills and expertise that art therapists have developed, which can be used to address the problems of autistic children.

The focus of current research has shifted (across disciplines in general) to focus on establishing procedures for obtaining early diagnosis in order to produce effective management plans which could be implemented in the pre-school years. We consider that the model of art therapy for autistic children presented here could be an active part of the management or treatment of autism from first diagnosis, however early this may be.

The methodology we have employed identifies for us ways in which the art-making process can be effective in establishing a therapeutic relationship with autistic children. For example by using categories of early infant mark-making, it is possible to identify the schematic (or anomalous) nature of the development of autistic children's approach to mark-making and relate this to the specific difficulties they experience with communication.

In conjunction with this and in response to the communicative sensitivity of children with autism, the indications are that working with an interactive approach based on theories of infant–caregiver interactions in very early infancy is effective. Using this approach it has been possible to achieve attunement between the therapist and child, opening up the possibilities towards monitoring and stabilising a working alliance into which interventions could be introduced that addressed their schematic art making activity. In this way a therapeutic relationship can be established.

It must also be stressed that in emphasising the importance of establishing the working alliance we are not implying that art-making processes as an intervention are introduced after the working alliance has been established. What we have attempted to make clear is that the art materials and art-making processes are an integral part of the art therapy from the beginning of the treatment. As such they are one of the most important elements in the art therapy as they provide an indirect focus and shared engagement between therapist and client. By directing social interaction through a focus on the art-making activity, a form of relating which children with autism can tolerate, and build up a tolerance for, becomes established.

Running concurrently with assessment and monitoring (maintaining the stability of the working alliance) of the interactive approach, the possibilities for a second line of interventions develop. These interventions assess the autistic children's engagement in art-making processes and the art work they produce, and take note of the

schematic features of this material. The interventions made from this assessment are based on the pre-representational drawing activities employed by infants at the earliest stage of drawing development and the activities following this first phase through to representational drawing. By introducing further materials and activities or limiting these in the art therapy with autistic children, they are exposed to a quality of experience equivalent to phases of the very early stages of infant development, the dynamics of which pre-form the development of the capacity to symbolise.

Conclusion

With its focus on helping with the psychological and emotional development of the child, art therapy can offer a very focused form of primary intervention. Further, because art involves a complex developmental process, art therapy can also be seen to be effective at behavioural and cognitive levels.

Throughout this book we have emphasised that the early phases of drawing development, the pre-representational drawing activities, are particularly helpful in engaging autistic children in experiences which provide a foundation for the development of communicative skills generally, if these are to appear. In other words, our method of therapeutic intervention using art developed for this model of art therapy provides a 'communicative scaffolding' onto which further development, including an increase in the use of verbal language, can hang.

References

Alcorn, A. and Bretherton, K. (1997) 'The Laboratory Diagnosis of Autism.' Paper presented to conference organised by the Autism Research Unit and supported by the National Autistic Society and the University of Sunderland, *Living and Learning with Autism: Perspectives from the Individual, the Family and the Professional,* Durham.

Alvarez, A. (1992) *Live Company.* London: Routledge.

American Psychiatric Association (1994) *Diagnostic and Statistical Manual for Mental Disorder (DSM-IV).* Washington, DC: American Psychiatric Association.

Baron-Cohen, S. (1992) 'The Theory of Mind Hypothesis of Autism: History and Prospects of the Idea.' *The Psychologist: Bulletin of the British Psychological Society 5,* 9–12.

Baron-Cohen, S., Allen, J. and Gillberg, C. (1992) 'Can Autism be Detected at 18 Months? The Needle, the Haystack and the CHAT.' *British Journal of Psychiatry 161,* 839–843.

Bondy, A.S. (1996) *The Pyramid Approach to Education.* Cherry Hill, NJ: Pyramid Educational Consultants.

Bowlby, J. (1965) *Child Care and the Growth of Love.* Harmondsworth: Penguin.

Bowlby, J. (1969) *Attachment.* Volume I of *Attachment and Loss.* London: Hogarth Press.

Brazelton, T.B., Koslowski, B. and Main, M. (1974) 'The Origins of Reciprocity: The Early Mother–Infant Interaction.' In M. Lewis and L.A. Rosenblum (eds) *The Effect of the Infant on its Caregiver.* New York: John Wiley.

Collins, M., Gould, J. and Mills, R. (1995) *Common Ground: Report on a Visit by the National Autistic Society to the Boston Higashi Society 5–9 November 1995.* London: National Autistic Society.

Condon, W.S. and Sander, L.W. (1974) 'Neonate Movement is Synchronised with Adult Speech: Interactional Participation and Language Acquisition.' *Science 183,* 99–101.

Dubowski, J. (1984) 'Alternative Models for Describing the Development of Children's Graphic Work: Some Implications for Art Therapy.' In T. Dalley (ed) *Art as Therapy: An Introduction to the Use of Art as a Therapeutic Technique.* London: Routledge.

Dubowski, J. (1990) 'Art versus Language: Separate Development during Childhood.' In C. Case and T. Dalley (eds) *Working with Children in Art Therapy*. London: Routledge.

Elgin, M. (1998) *The Psychoanalytic Mystic*. London: Free Association.

Evans, K. and Rutten-Saris, M. (1998) 'Shaping Vitality Affects – Enriching Communication.' In D. Dandle (ed) *Development and Diversity: New Applications in Art Therapy*. London: Free Association.

Freeman, N. (1985) *Visual Order: The Nature and Development of Pictorial Representation*. Cambridge: Cambridge University Press.

Gillingham, G. (1995) *Autism: Handle with Care. Understanding and Managing Behaviour of Children and Adults with Autism*. Arlington, TX: Future Education Inc.

Grandin, T. and Scariano, M. (1986) *Emergence Labelled Autistic*. Tunbridge Wells: Costello.

Grayson, A. and Grant, K. (1995) 'Psychological Persectives in Autism.' Conference proceedings of conference organised by the Autism Research Unit and the National Autistic Society, University of Durham.

Jordan, R., Jones, G. and Murray, D. (1998) *Educational Interventions for Children with Autism: A Literature Review of Recent and Current Research*. London: Department for Education and Employment.

Lowenfeld, V. and Brittain, W.L. (1987) *Creative and Mental Growth*, 8th edn. New York: Macmillan.

Lucquet, G.H. (1929) 'L'evolution du Dessin Enfantin.' *The Bulletin of the Binet Society 29*, 145–163.

Mahler, M.S., Pine, F. and Bergman, A. (1985) *The Psychological Birth of the Human Infant: Symbiosis and Individuation*. London: Karnac Books.

Matthews, J. (1984) 'Children's Drawings: Are Young Children Really Scribbling?' *Early Child Development and Care 18*, 1–39.

Meltzer, D., Bremner, J., Hoxter, S., Weddell, D. and Wittenburg, I. (1975) *Explorations in Autism: A Psycho-analytical Study*. Strath Tay, Perthshire: Clunie Press.

Miedzianik, D. (1986) *My Autobiography*. Nottingham: Child Development Research Unit, University of Nottingham.

Montagner, H., Restoin, A. and Henry, J.C. (1982) 'Biological Defense Rhythms, Stress, and Communication in Children.' In W.W. Hartup (ed) *Review of Child Development Research, 6*. Chicago: University of Chicago Press.

Nind, M. and Hewett, D. (1994) *Access to Communication: Developing the Basics of Communication with People with Severe Learning Difficulties through Intensive Interaction*. London: David Fulton.

Piaget, J. and Inhelder, B. (1969) *The Psychology of the Child*. London: Routledge and Kegan Paul.

Rutten-Saris, M. (1990) *Basiboek Lichaamstaal*. Assen: Van Gorcum.

Sandle, D. (1998) *Development and Diversity: New Applications in Art Therapy*. London: Free Association.

Schore, A.N. (1999) *Affect Regulation and the Origin of the Self*. Hillsdale, NJ: Lawrence Erlbaum.

Selfe, L. (1977) *Nadia: A Case of Extraordinary Drawing Ability in an Autistic Child*. London: Academic Press.

Selfe, L. (1983) *Normal and Anomalous Representational Drawing Ability in Children*. London: Academic Press.

Stern, D. (1985) *The Interpersonal World of the Infant*. New York: Basic Books.

Trevarthen, C., Aitken, K., Papoudi, D. and Robarts, J. (1998) *Children with Autism: Diagnosis and Interventions to Meet their Needs*, 2nd edn. London: Jessica Kingsley Publishers.

Trevarthen, C. and Neisser, U. (1993) *The Perceived Self: Ecological and Interpersonal Sources of Self Knowledge*. Cambridge: Cambridge University Press.

Tustin, F. (1981) *Autistic States in Children*. London: Routledge and Kegan Paul.

Williams, D. (1996) *Autism: An Inside-Out Approach*. London: Jessica Kingsley Publishers.

Williams, D. (1998) *Autism and Sensing: The Unlost Instinct*. London: Jessica Kingsley Publishers.

Wing, L. (1996) *The Autistic Spectrum*. London: Constable Press.

Winnicott, D.W. (1953) 'Transitional Objects and Transitional Phenomena: A Study of the First not me Possession.' *International Journal of Psychoanalysis 24*, 88–97.

Winnicott, D.W. (1971) *Playing and Reality*. London: Routledge.

Winnicott, D.W. (1991) *The Maturational Process and the Facilitating Environment: Studies in the Theory of Emotional Development*. Madison, CT: International University Press.

World Health Organisation (WHO) (1977, 1980, 1986) *Manual of the International Statistical Classification of Diseases, Injuries, and Causes of Death*. Geneva: WHO.

Subject Index

Author Index